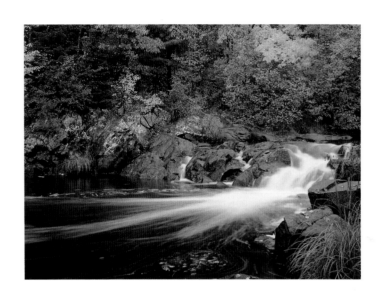

WISCONSIN

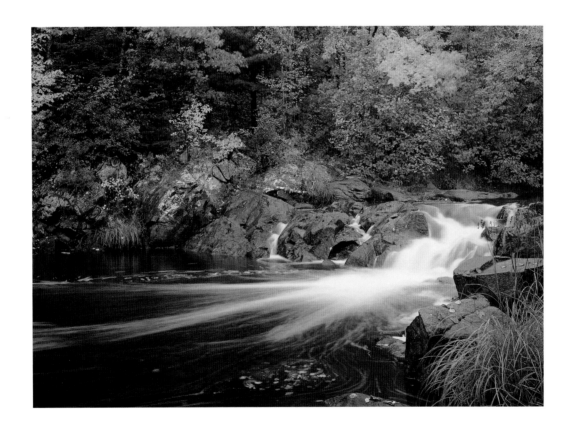

WHITECAP BOOKS
VANCOUVER / TORONTO / NEW YORK

Text by Tanya Lloyd
Edited by Elaine Jones
Photo editing by Tanya Lloyd
Proofread by Lisa Collins
Cover and interior design by Maxine Lea

Printed and bound in Canada

National Library of Canada Cataloguing in Publication Data

Lloyd, Tanya, 1973–

 Wisconsin

 (America Series)
 ISBN 1-55285-177-X

 1. Wisconsin—Pictorial works. I. Title. II. Series: Lloyd, Tanya,
1973 - America series
F582.L56 2001 977.5'044'0222 C2001-910269-0

The publisher acknowledges the support of the Canada Council and the Cultural
Services Branch of the Government of British Columbia in making this publication
possible. We acknowledge the financial support of the Government of Canada through
the Book Publishing Industry Development Program for our publishing activities.

For more information on the America Series and other Whitecap Books
titles, please visit our web site at www.whitecap.ca.

Some of Wisconsin's best-loved sights seem to have been created especially for visitors – the picturesque lighthouses along rugged Great Lakes shorelines, the historic vessels moored in maritime museums, the crops spread over rolling hills, and the orchards planted in neat, blossoming rows. But each of these sights attests not only to the state's natural bounty, but also to the rich and varied history of the region – a legacy of settlers and entrepreneurs who arrived here from countries around the world.

Before French explorer Jean Nicolet charted the shores of Wisconsin in 1634, this was a land rich in fur and forests, boasting a network of rivers plied by native traders. It wasn't until the eighteenth century that timber barons arrived to harvest the lush pine forests and mine the region's hills for ore. French and British immigrants looking for a new way of life were joined by settlers from Germany and Luxembourg, Norway and Ireland.

Who were their descendants? Author Laura Ingalls Wilder, typewriter inventor Christopher Latham Sholes, and women's suffrage activist Carrie Chapman Catt all hailed from Wisconsin. The Ringling Brothers gave their first circus performance here, and Methodist minister John Carhart created the world's first steam-powered automobile. In other parts of the state, farmers were forming a dairy association that would eventually bring international fame to Wisconsin's cheese. Engineers were building a hydro-electric dam and a university professor was perfecting the first round silos. And all of this by the end of the nineteenth century.

The photographs in *Wisconsin* reveal the state's panoramic views, its unique architecture, and its vast parkland. But behind each building or monument lies the vision of an inventor or the dream of a settler – something impossible to capture on film, but a major part of the life and vitality a visitor will discover in Wisconsin today.

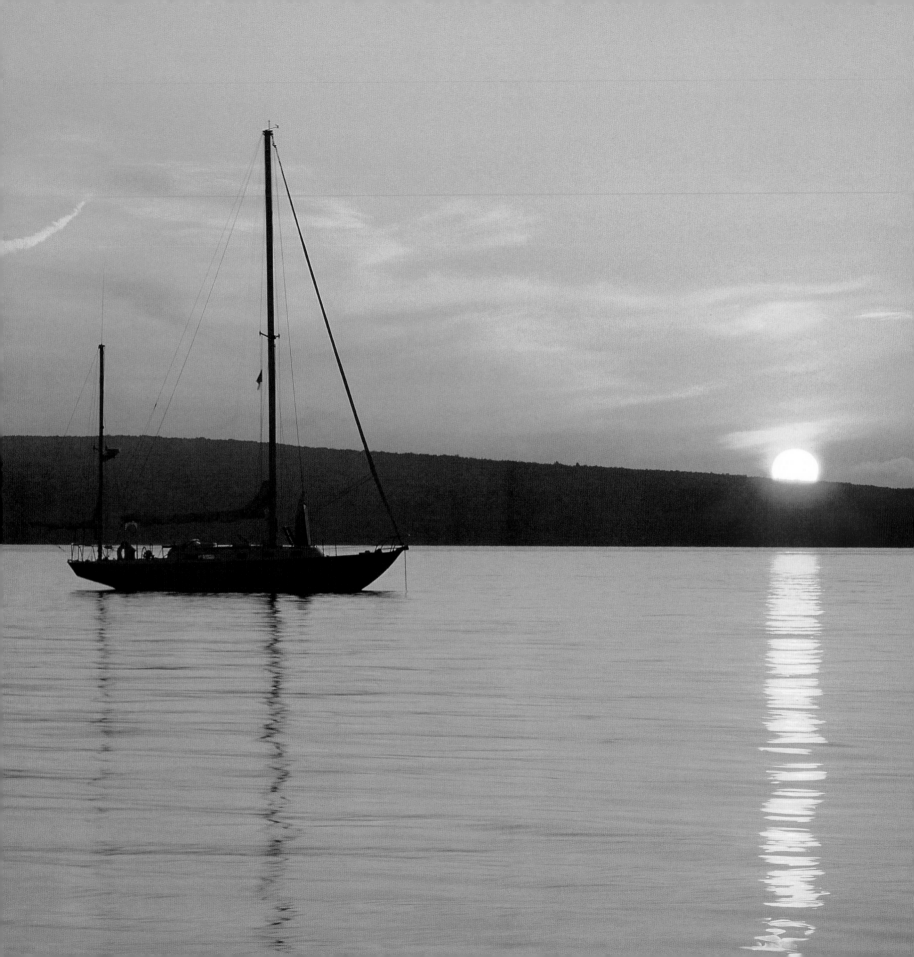

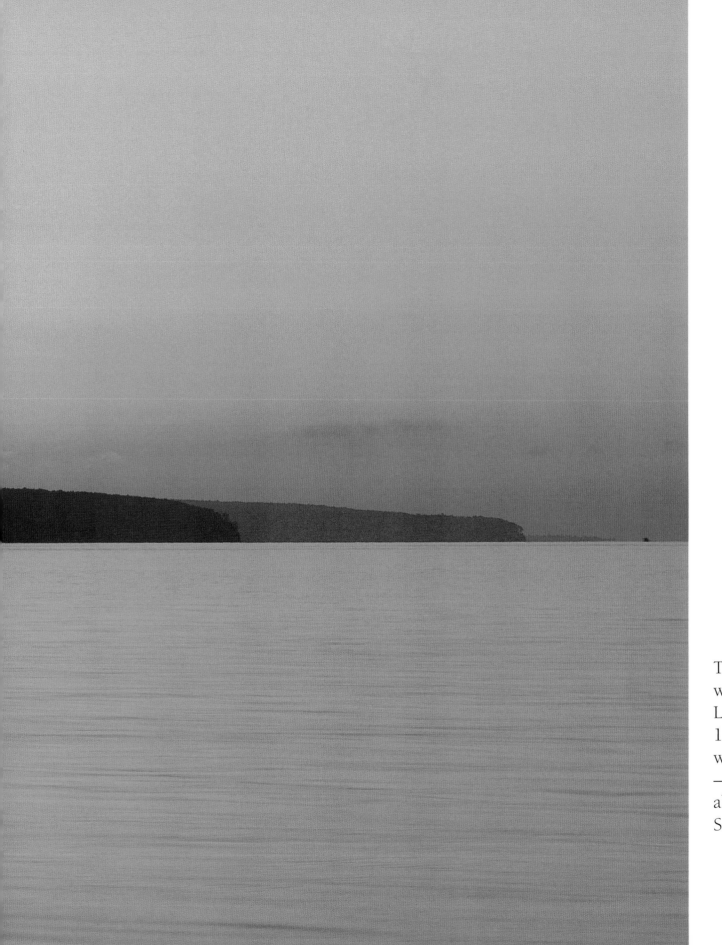

The largest fresh-water lake on earth, Lake Superior holds 10 percent of the world's water supply – enough to flood all of North and South America.

Apostle Islands National Lakeshore includes 22 islands, along with 12 miles of the shoreline along Lake Superior. The park protects unique ecosystems, along with lighthouses and ship-wreck sites – remnants of the region's history.

FACING PAGE—
The Apostle Islands were named in honor of Jesus' apostles by the Jesuit missionaries. When they arrived during the seven-teenth century, they counted 12 islands, not the 22 that actually exist.

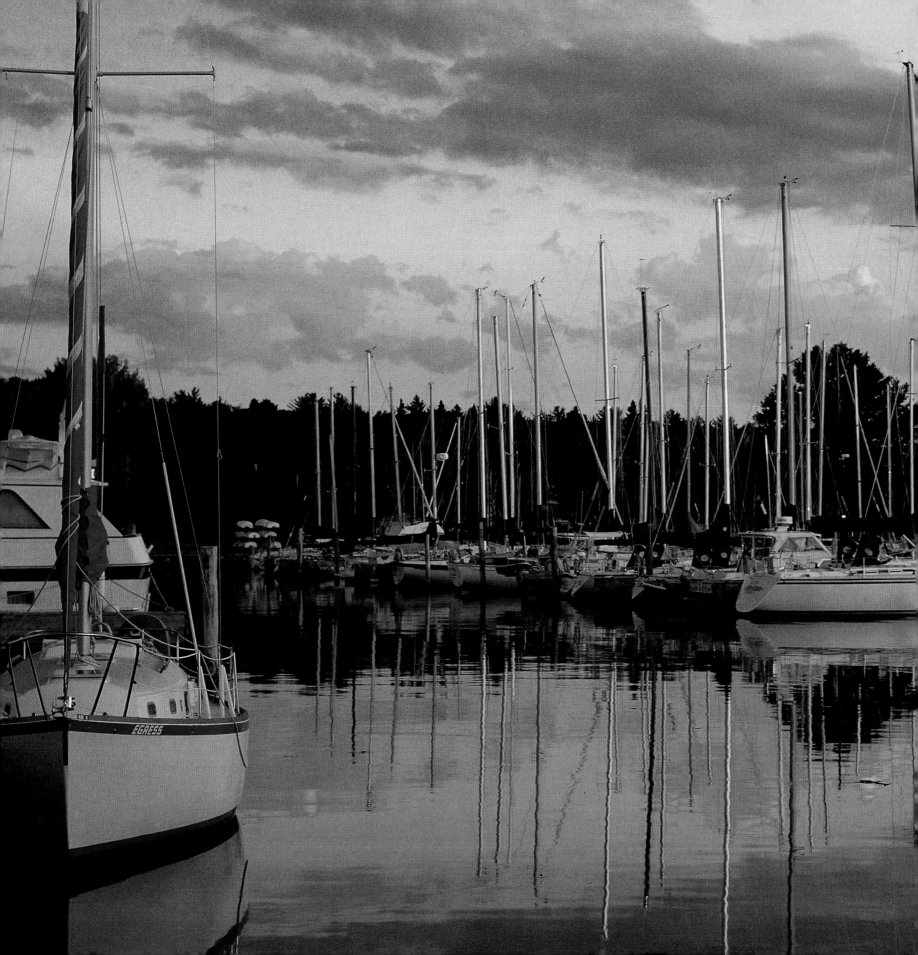

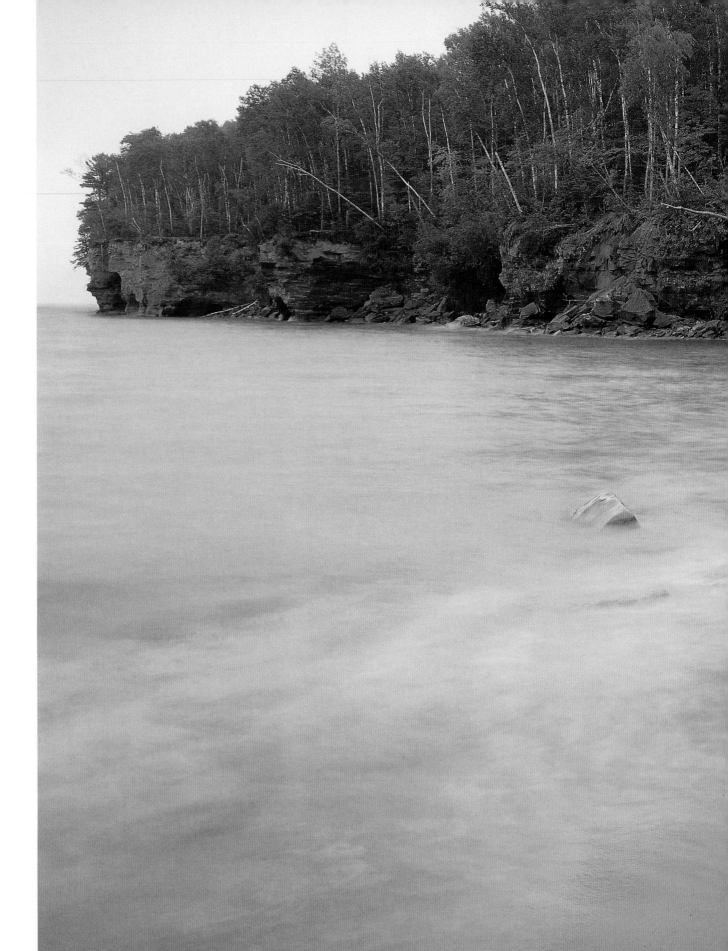

Big Bay State Park draws visitors to Madeline Island, one of the Apostle Islands in Lake Superior. Campsites overlooking the sandstone bluffs and beautiful lake waters make this a favorite family destination.

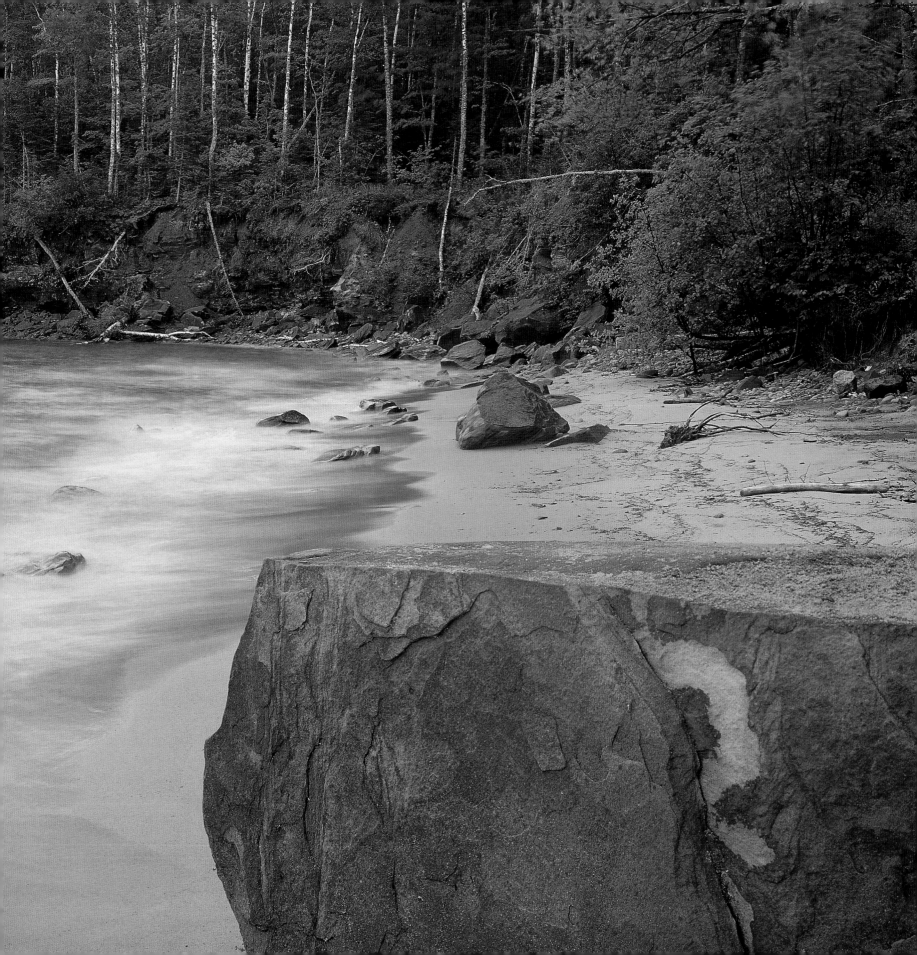

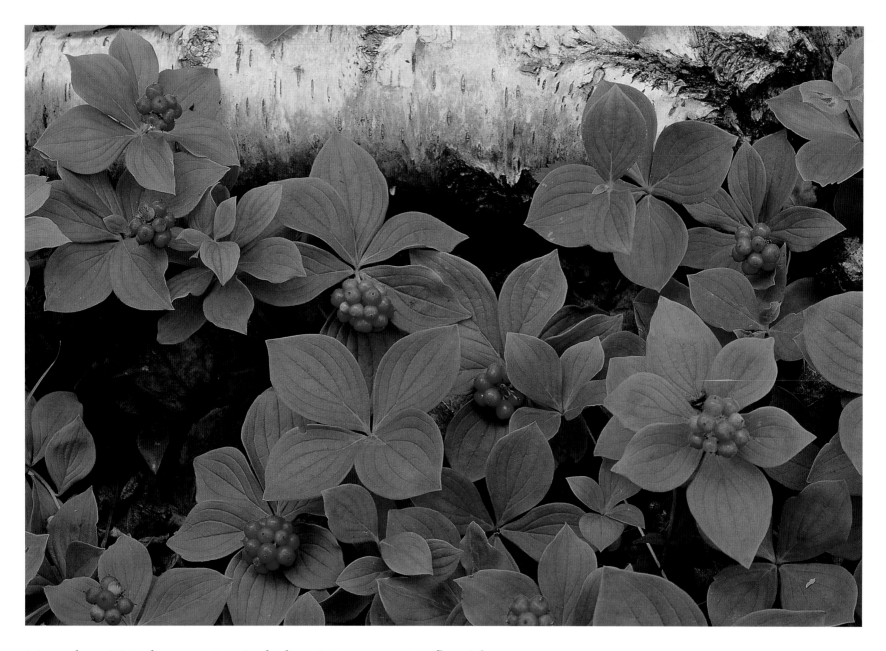

More than 803 plant species, including 37 rare species, flourish within Apostle Islands National Lakeshore. A number of mammal species also make their home here, from tiny brown bats to black bears that swim between the islands.

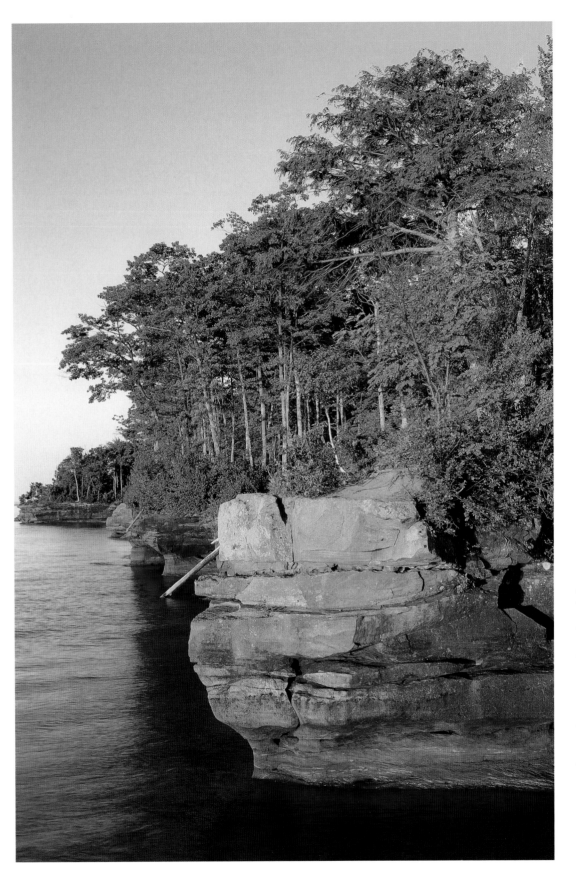

Standing atop the Apostle Islands' sandstone cliffs, these evergreens are part of the circumpolar boreal forest, which extends through Canada to the southern shores of Lake Superior. South of this point, the forest gives way to northern hardwoods.

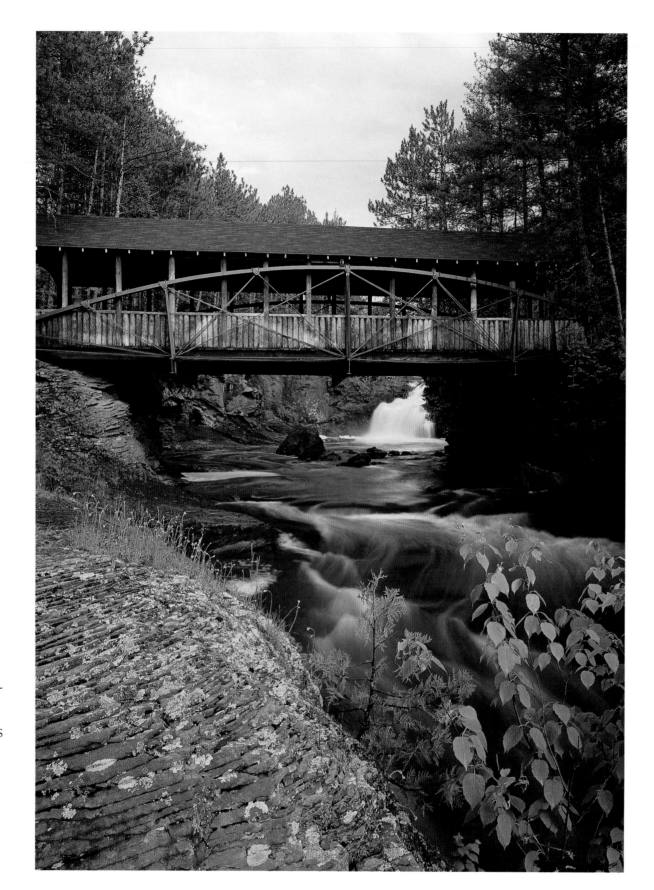

From a covered footbridge over the Amnicon River, visitors gain spectacular views of the waterfalls and rapids protected by the 825-acre Amnicon Falls State Park.

Wisconsin had been settled by native people for thousands of years before fur traders and missionaries arrived in the late 1600s. First explored by France, the land was passed to English rule after the French and Indian Wars of the 1700s.

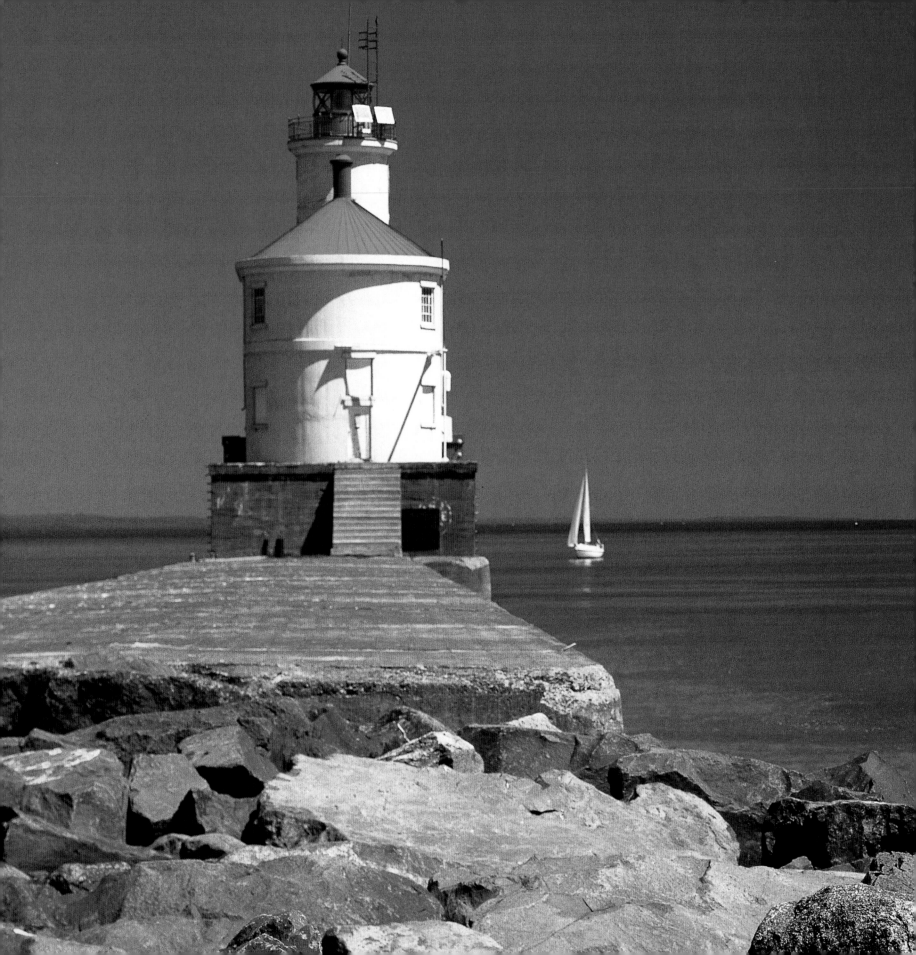

Wisconsin Point Lighthouse was built in 1913 to help guide vessels through the fog and into Superior Harbor. Two nearby buildings housed the lightkeepers before the beacon was automated in 1970.

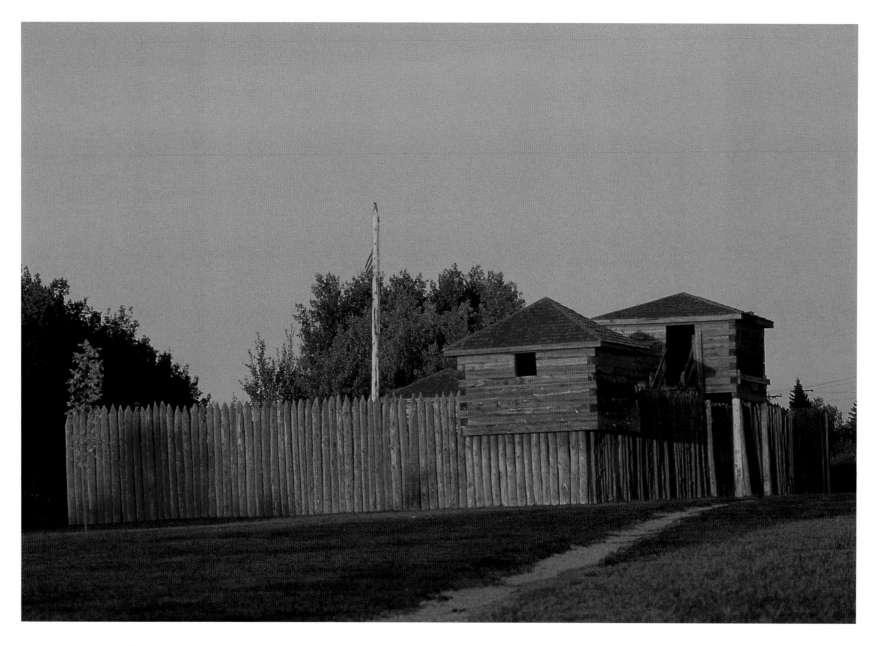

By the 1600s, fur traders were already traveling the shores of the
Great Lakes and exploring Wisconsin's rivers. A few of their forts
and outposts remain, allowing visitors to experience an afternoon
on the frontier.

With abundant pine and easily navigated rivers, Price County drew a stampede of loggers in the late nineteenth century. Most of the sawmills are now long gone and the county attracts visitors with more than 310,000 acres of public land.

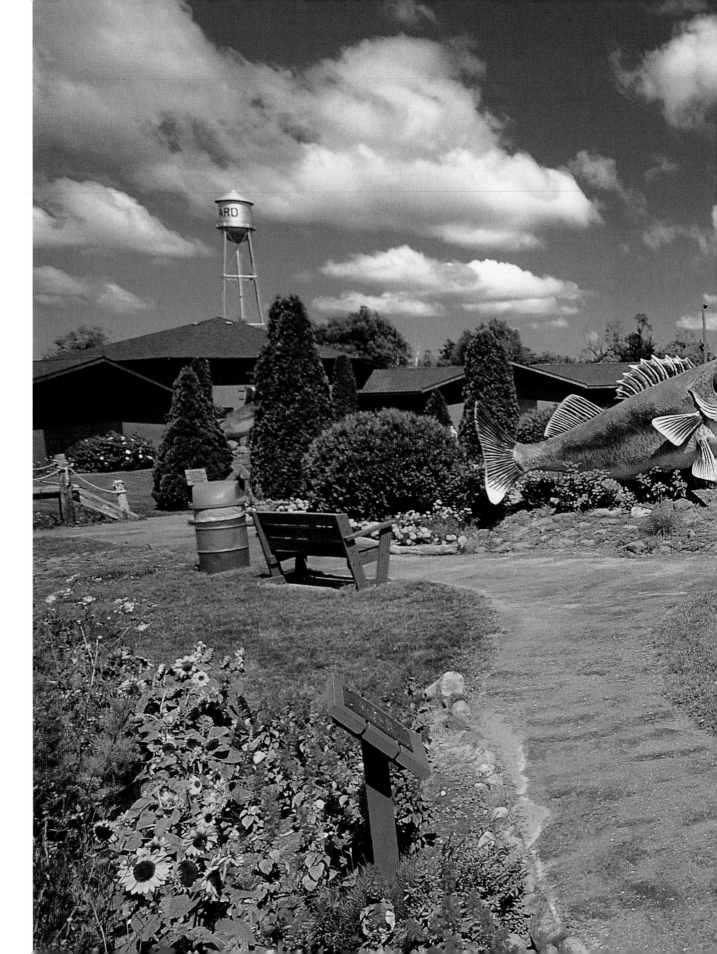

The National Freshwater Fishing Hall of Fame in Hayward is home to the world's largest fish, a fiberglass muskie. Fish enthusiasts can climb through the four-story creature to an observation deck built between its jaws.

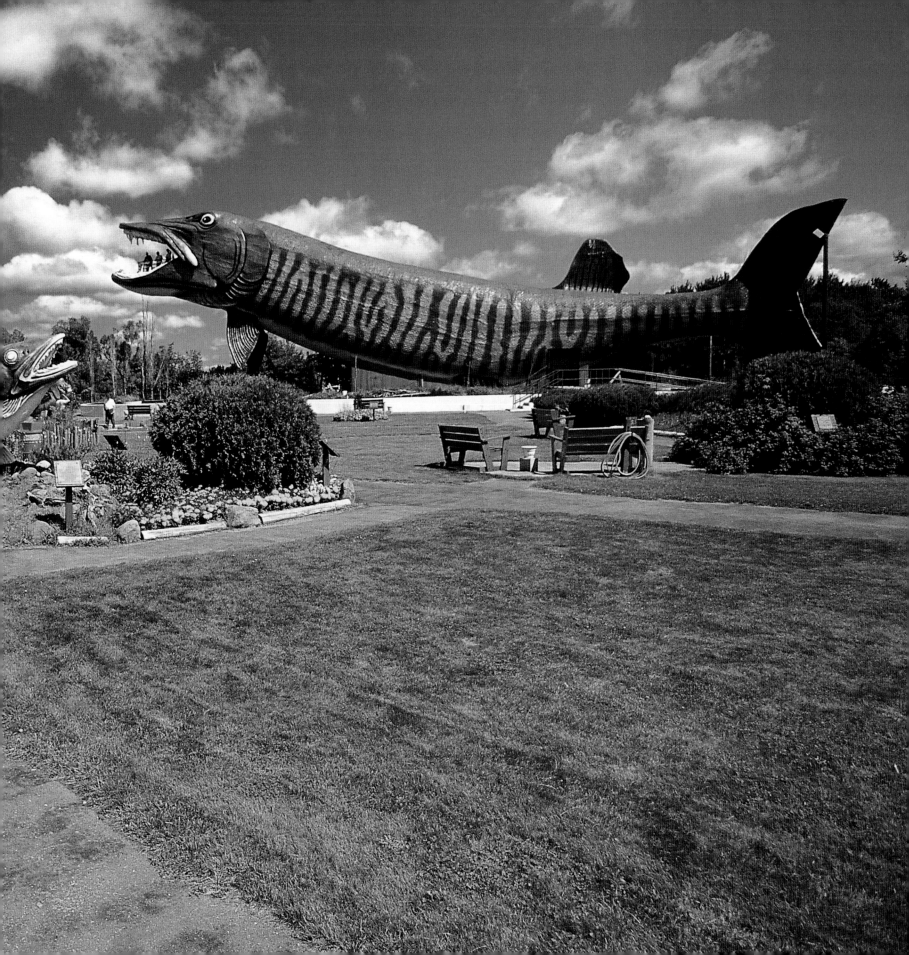

Chequamegon
National Forest
spans 858,400
acres of Wisconsin's
northwoods. Much
of this land was
heavily logged and
homesteaded in the
early 1900s. In
1928, the federal
government pur-
chased large tracts
in the area, and
President Herbert
Hoover established
the national forest
in 1933.

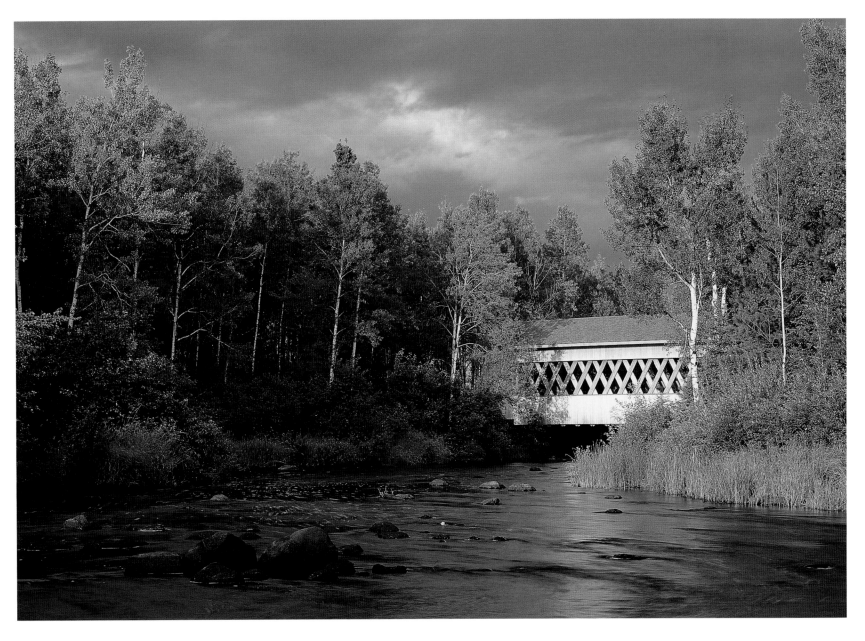

Chequamegon, meaning "place of shallow water," is the Ojibwa name for the bay to the north of the national forest. Along with the bay, the forest encompasses countless glacier-formed lakes and 632 miles of rivers and streams.

About 15 million white-tailed deer roam North America, as far north as Canada's Great Slave Lake and as far south as Mexico. The deer are named for the white patches, or flags, on the underside of their tails, visible as they leap away through the brush.

FACING PAGE—
With more than 200 miles of hiking trails, Chequamegon National Forest exposes visitors to the wilderness. Even in winter, cross-country skiers and snowmobile enthusiasts flock here to enjoy the pristine slopes.

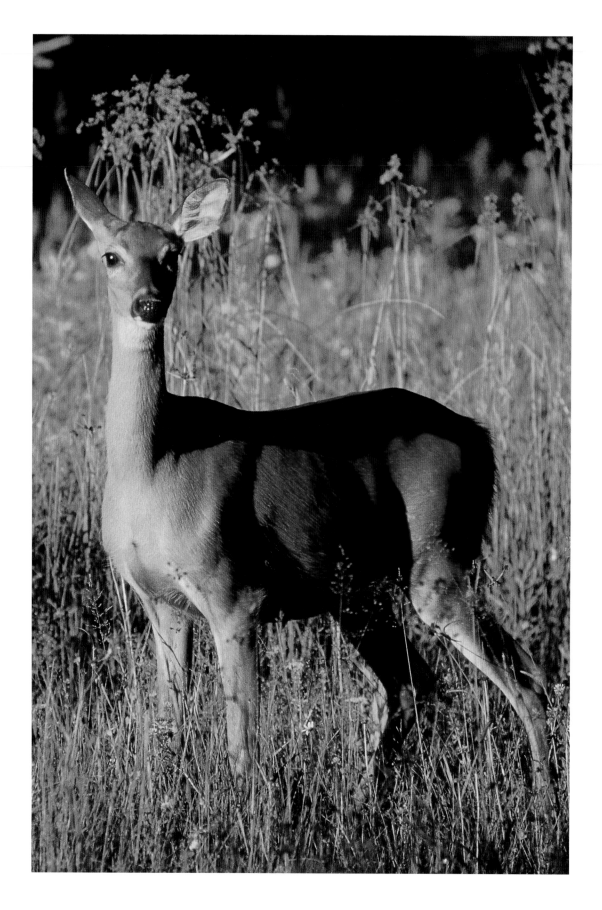

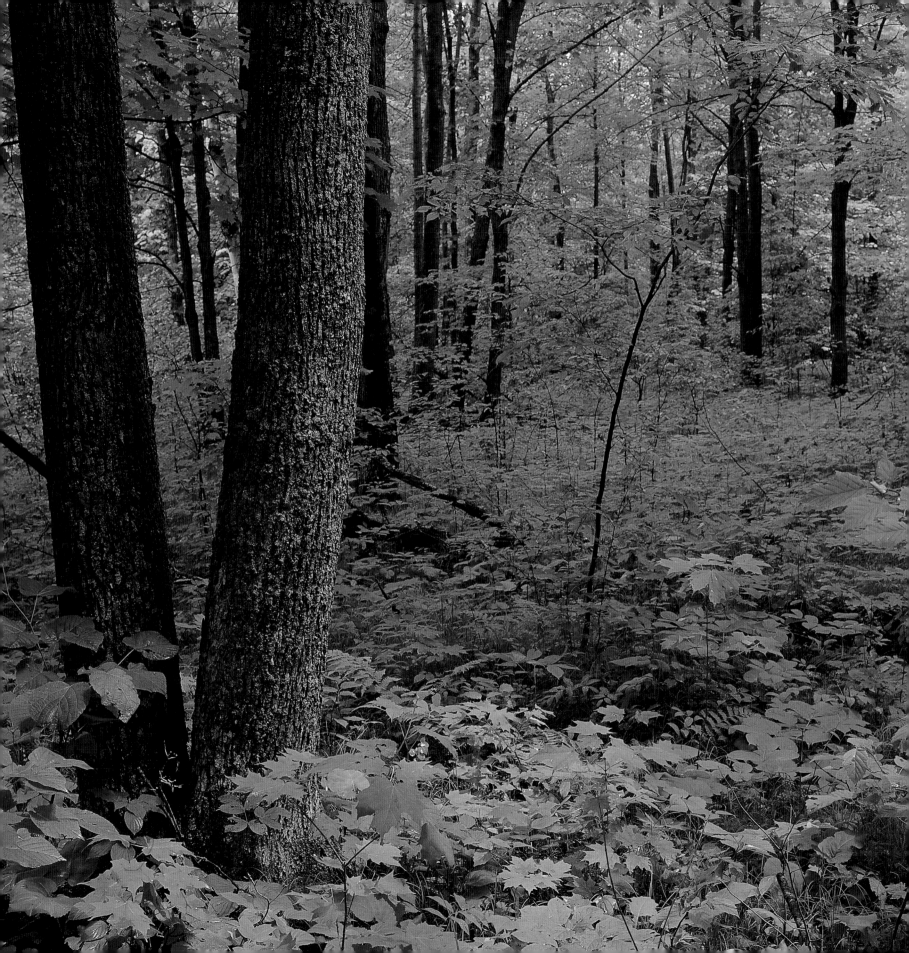

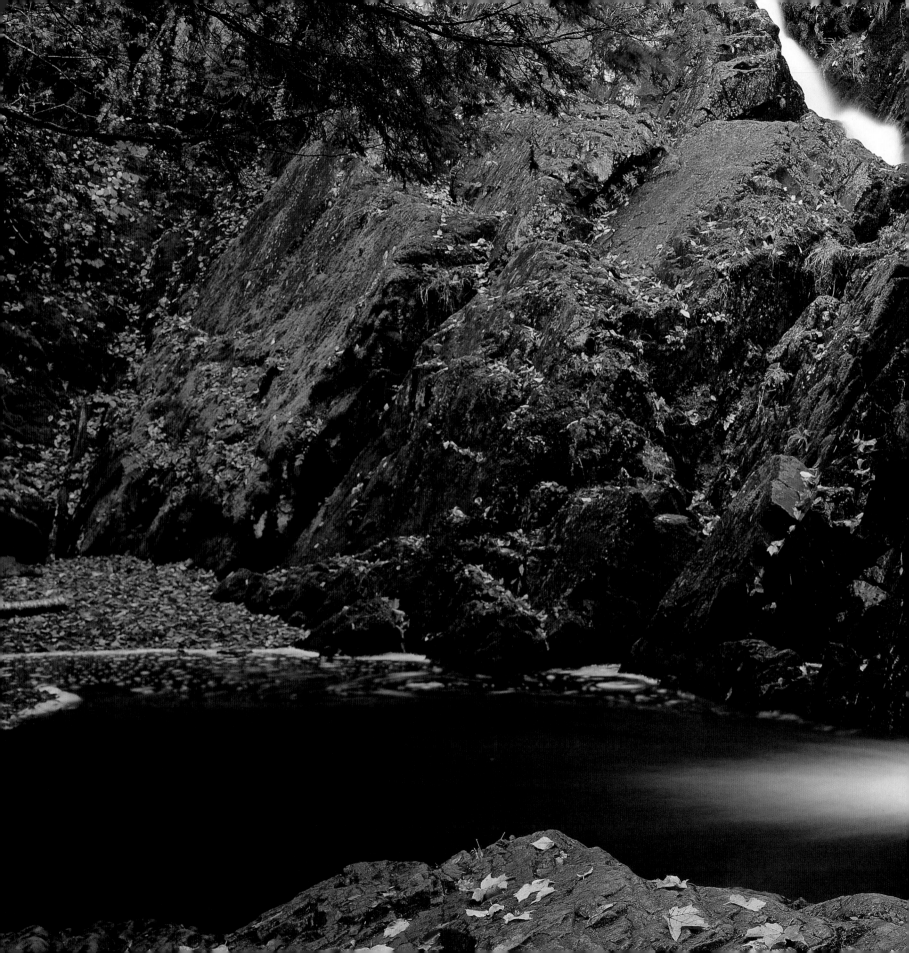

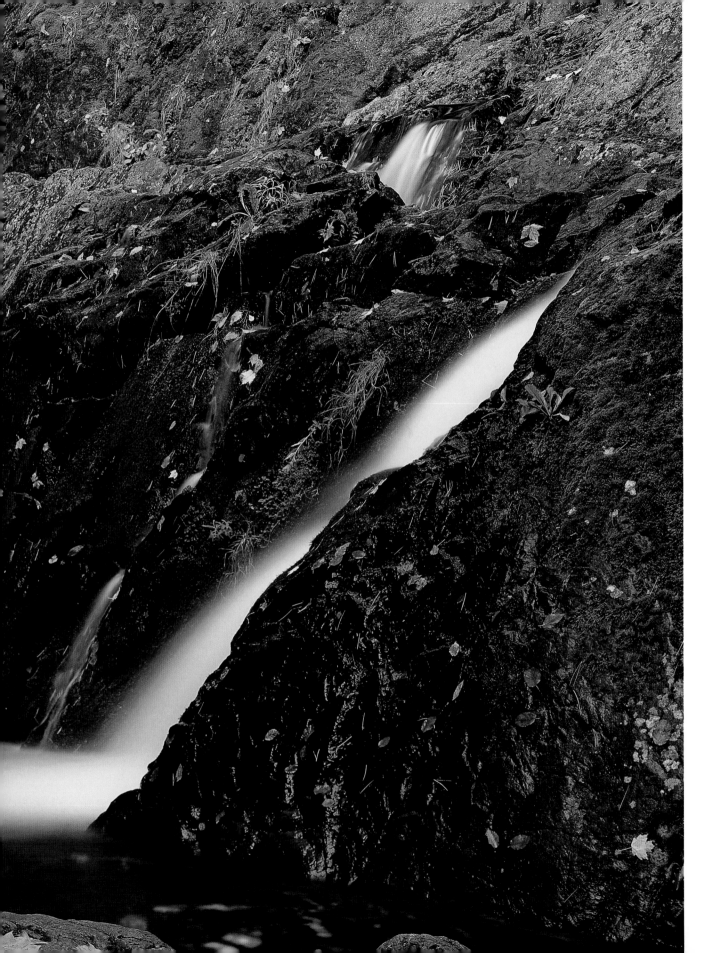

Adventurous visitors to Chequamegon National Forest can scale St. Peter's Dome, 1,710 feet above sea level. From there, they gain a view of three states, along with magnificent Morgan Falls, plummeting 80 feet down a granite wall.

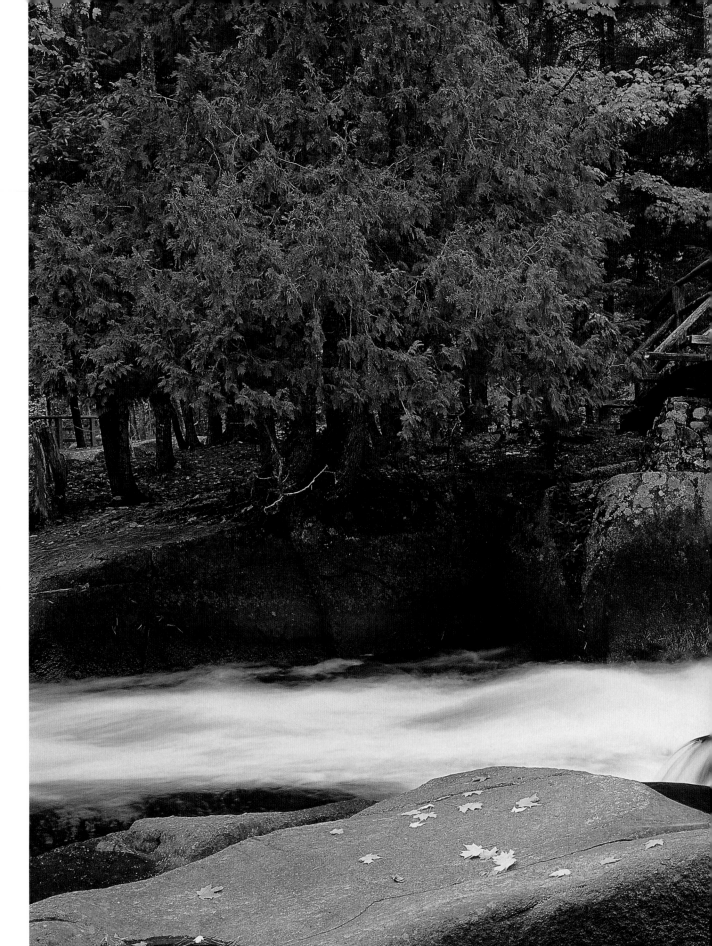

Trout fishing, hiking, and secluded camp-sites draw campers to Goodman Park, where a footbridge arches over the Peshtigo River. Downstream, the Peshtigo becomes one of Wisconsin's most popular rafting rivers.

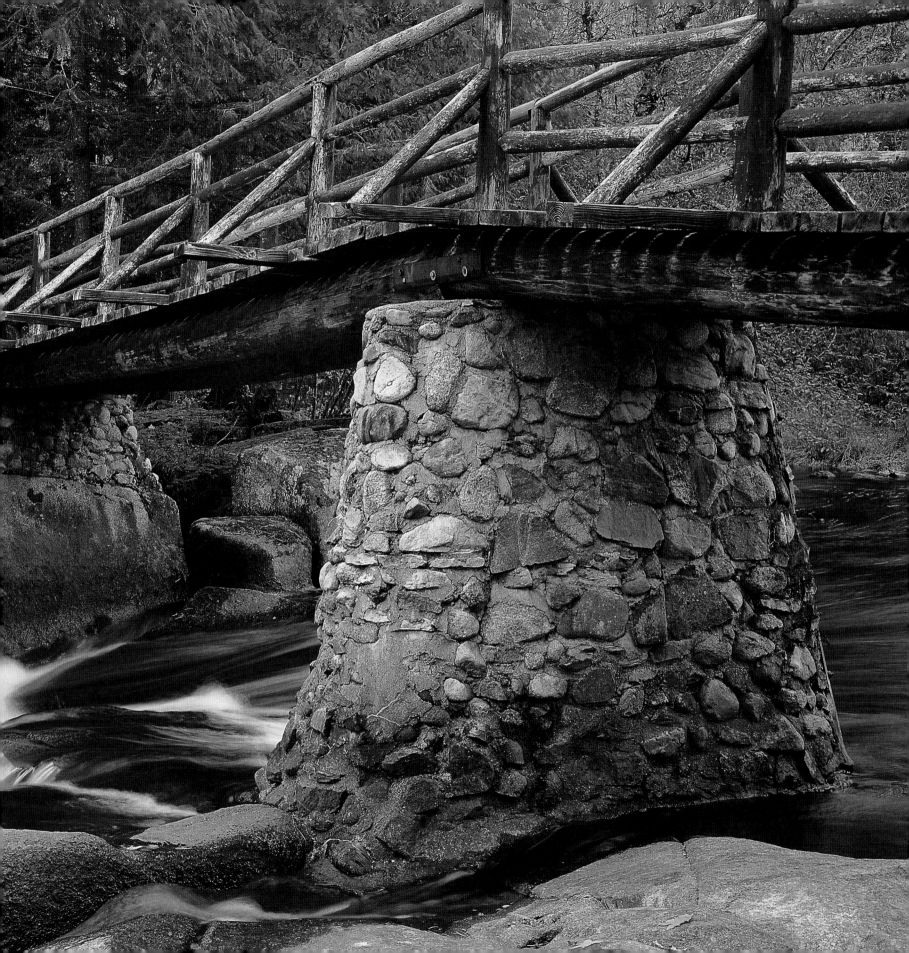

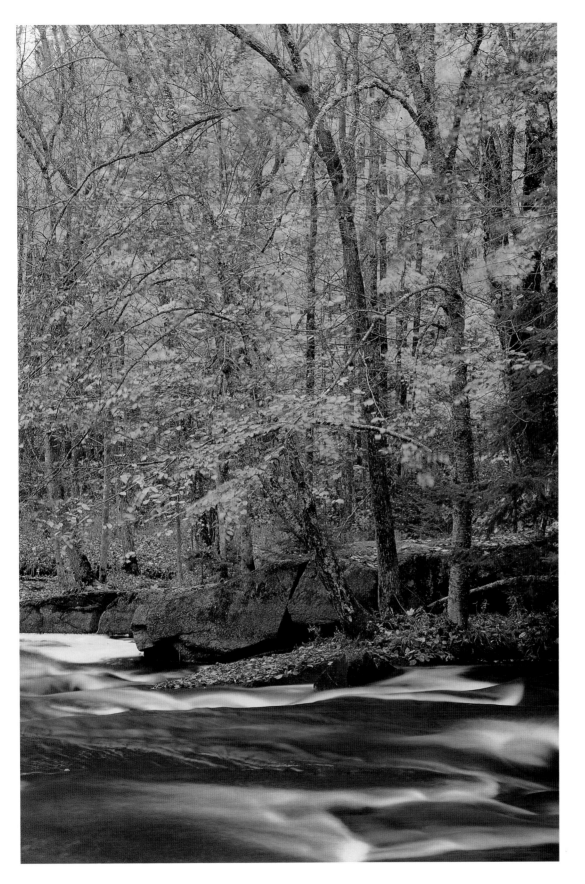

Marinette County is named for Marguerite Chevalier, daughter of a Canadian trader and a native woman. In the 1830's, after two marriages and six children, Marguerite took over the operation of the local trading post, earning renown for her business abilities and the nickname "Queen Marinette."

FACING PAGE—
Though just a short drive from Minneapolis, the shores of the St. Croix and Namekagon rivers have escaped major development. In 1968, the St. Croix National Scenic Riverway was created to protect 252 miles of the pristine shoreline.

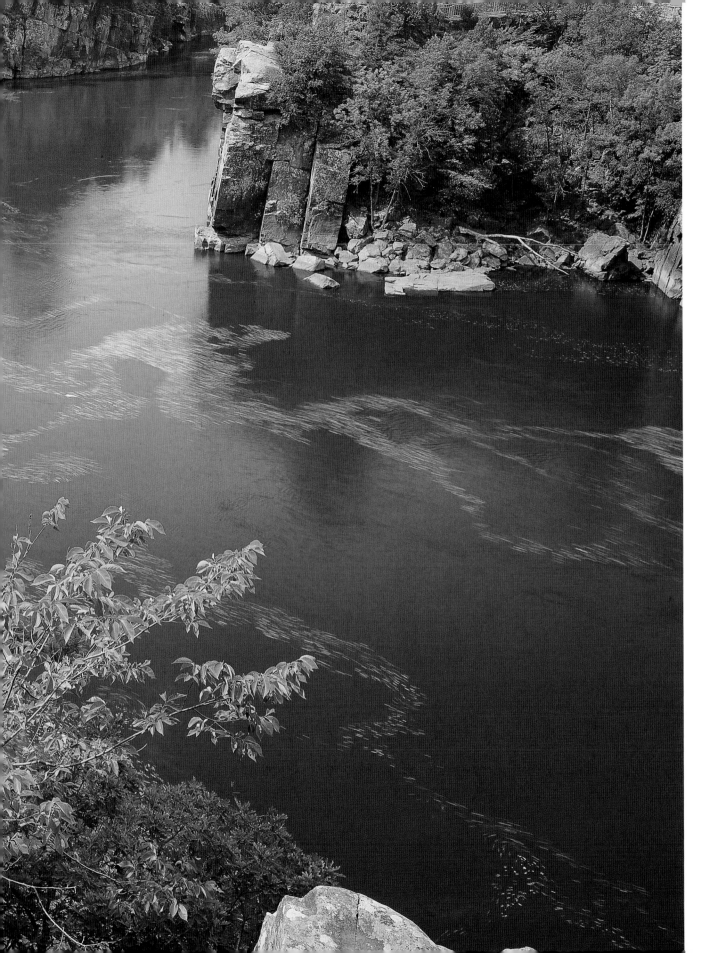

Basalt cliffs tower over the Lower St. Croix River in an area known as the Dalles, formed by the glaciers of the last ice age. Here, the usually serene river flows deep and fast through the narrow channel.

33

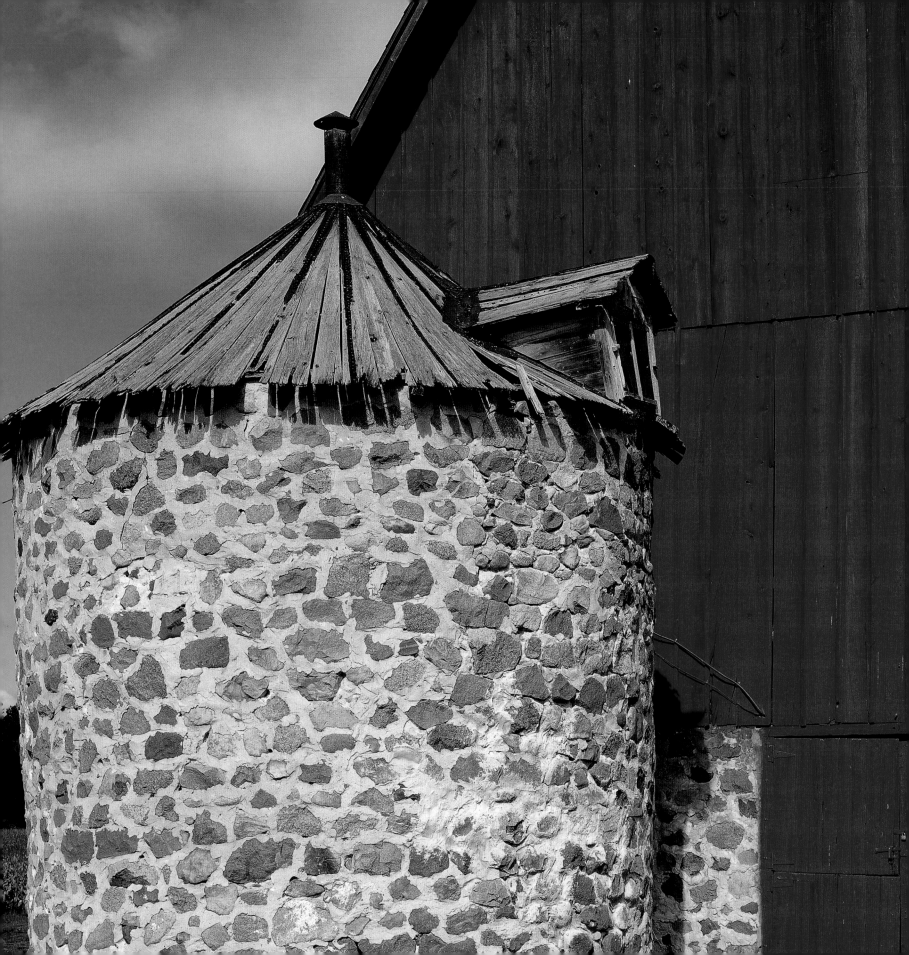

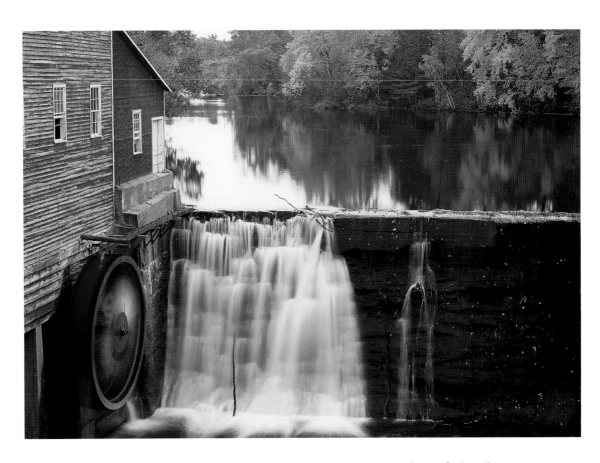

A waterwheel remains in Eau Claire County, a reminder of the days of homesteads and lumber camps. Today, this is one of Wisconsin's favorite resort areas, dotted with lakes and campgrounds.

When traders first traveled Wisconsin, they were forced to portage their canoes between the Fox and Wisconsin rivers, giving Portage County its name. Today, this region is lush with sprawling farms, abundant streams, and more than 130 lakes.

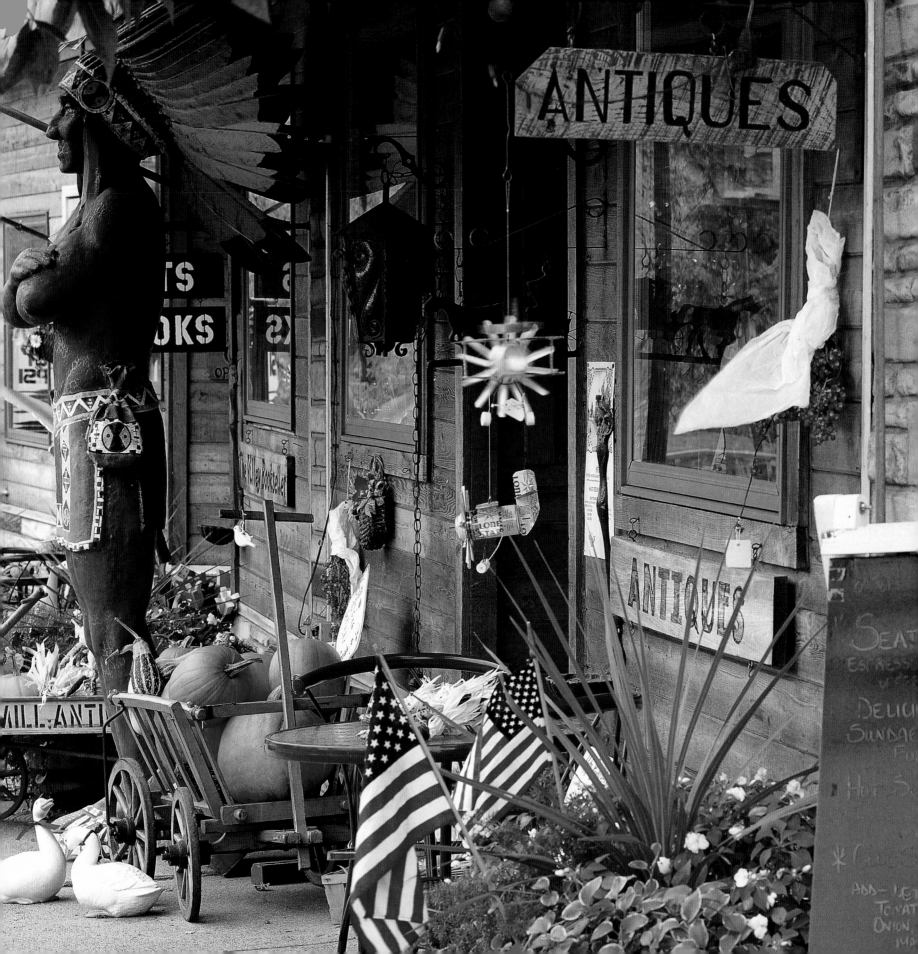

Allen Lake reflects a clear blue sky over Hartman Creek State Park. Archeologists have discovered that the park, now a popular camping destination with more than 100 sites, was once a gathering place for First Nations peoples.

In the 1800s, steamboats docked at Osceola, where passengers could walk to a nearby waterfall. Today's visitors travel by train aboard historic steam engines chugging towards Minnesota.

Fountain City draws
its charm from the
steep mountain bluffs
on one side and the
Mississippi River on
the other. Its position
on the Great North-
ern Flyway makes
this an important
stop for migrating
birds, and a favorite
destination for bird-
watchers.

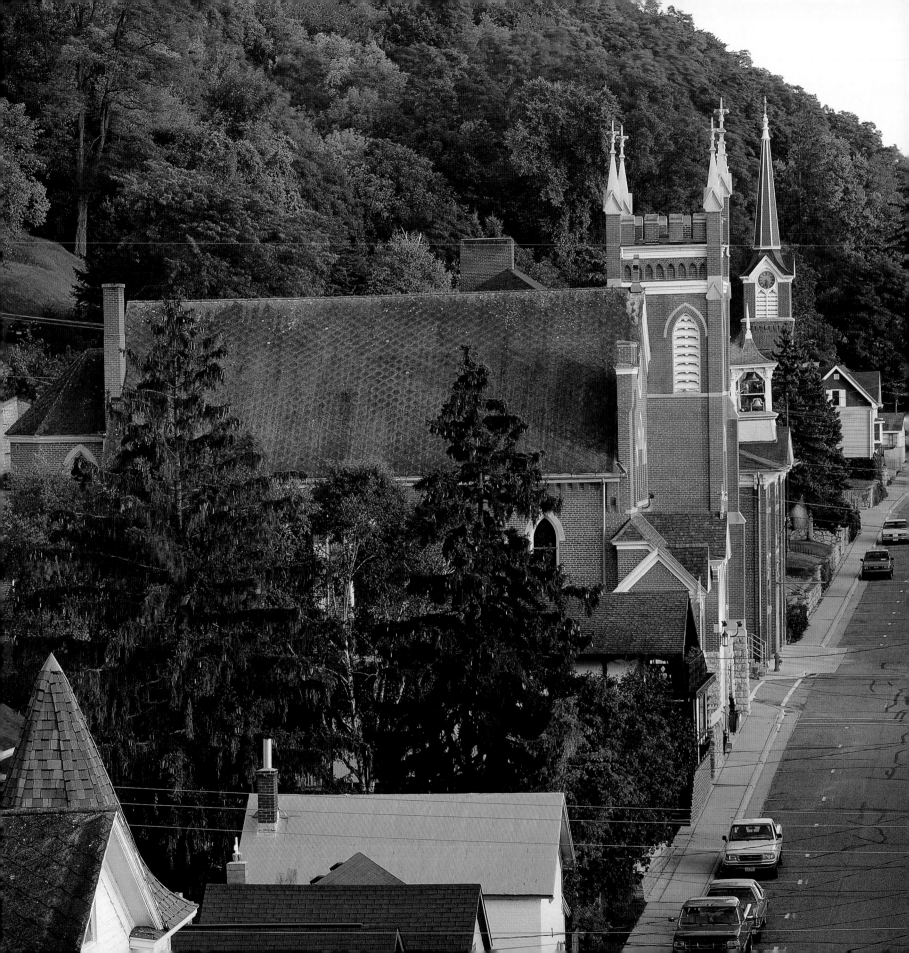

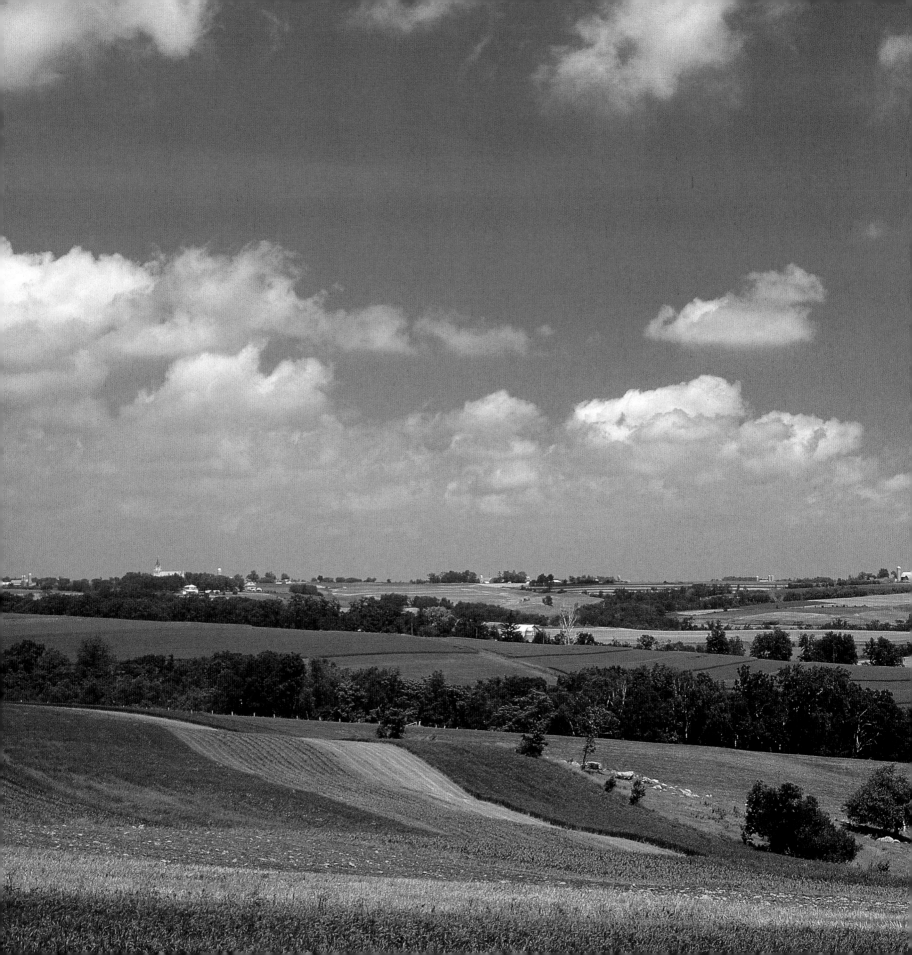

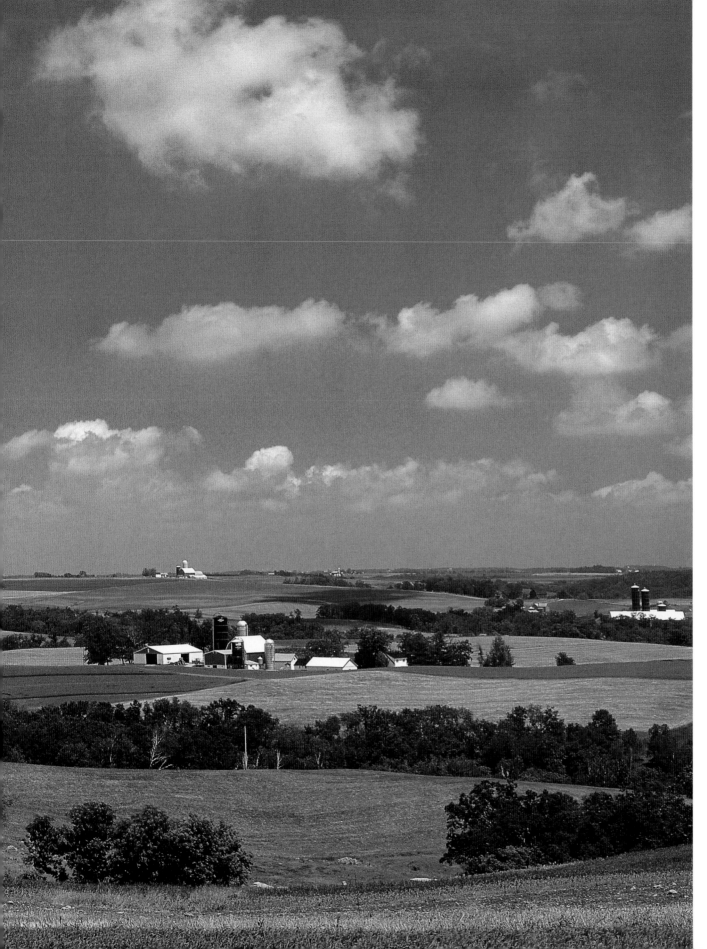

Wisconsin is the second-largest milk producer in the nation, and supplies about a third of America's cheese. Fruit, vegetables, oats, and hay are also leading agricultural crops.

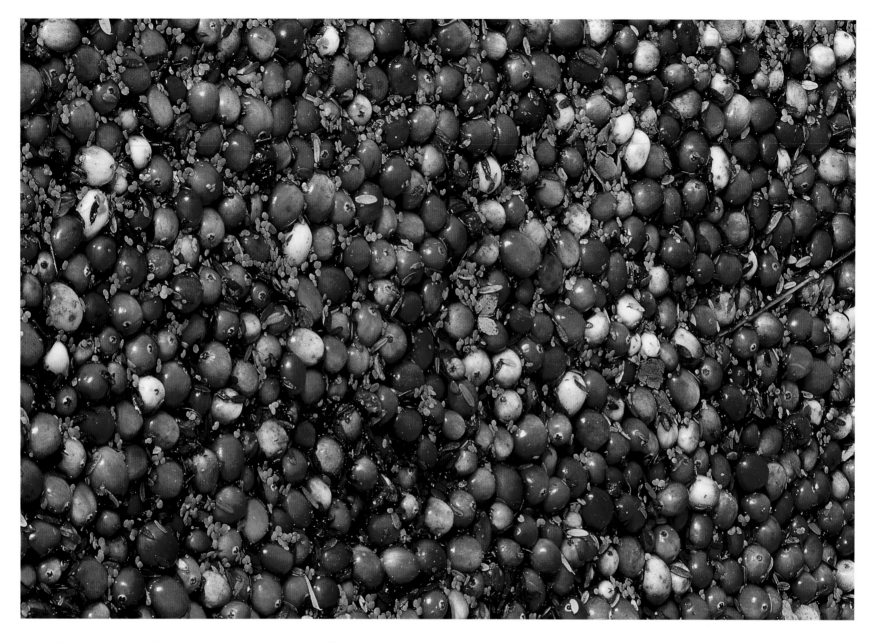

Cranberry vines bloom in Wisconsin's sandy soil in late May. When the summer flowers open, growers ship in millions of bees to help pollinate the plants. Then, when the berries have matured in September, the beds are flooded and the fruit collected.

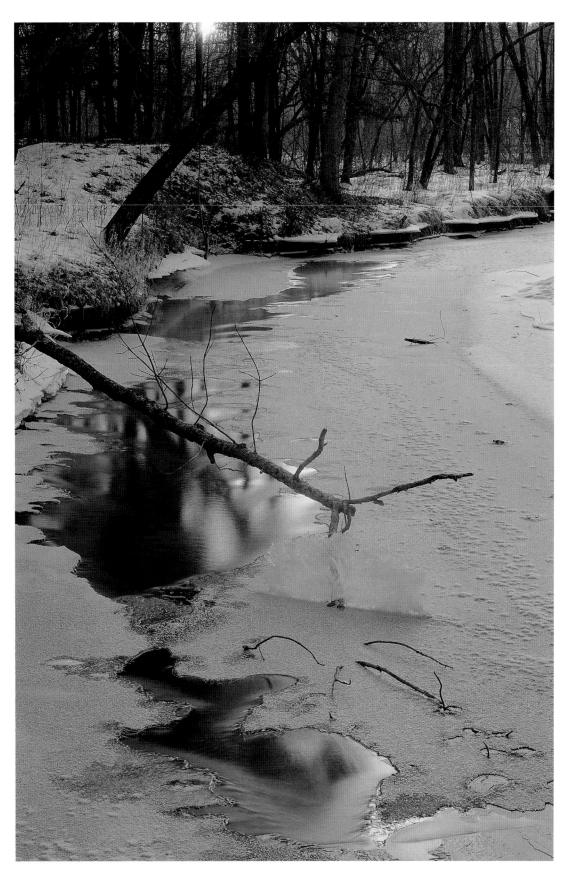

Roche-a-Cri State Natural Area is a pristine reserve rising up to 300 feet above the surrounding plains. Nearby, petroglyphs have weathered the centuries.

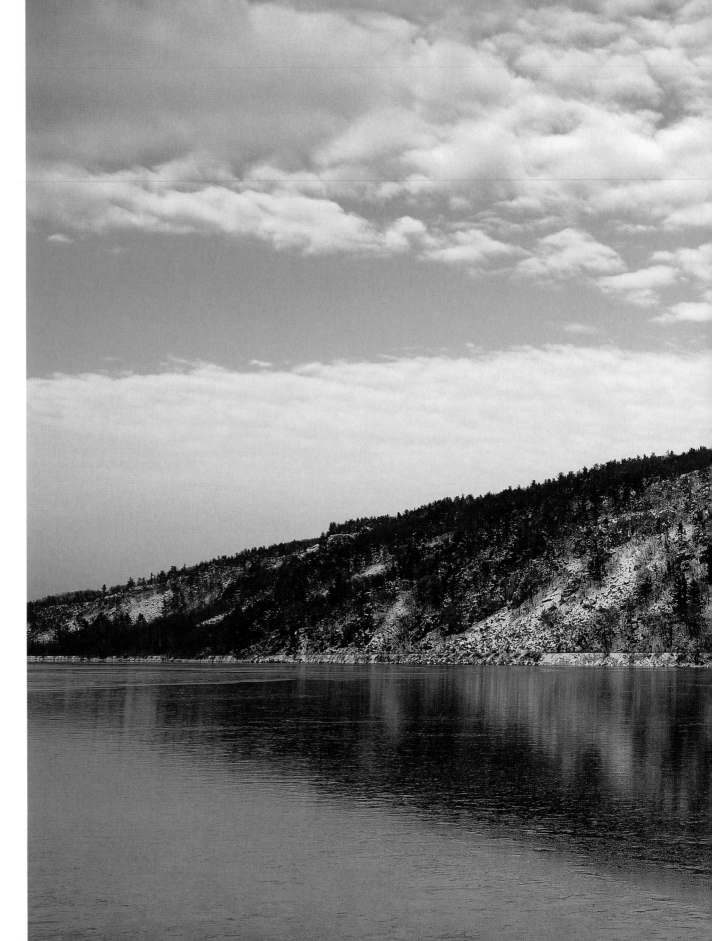

Devil's Lake State Park offers more than the usual hiking trails. Mountain bikers grind their way to the top of the bluffs, divers explore the rocky lake bottom, and rock climbers scale the cliffs.

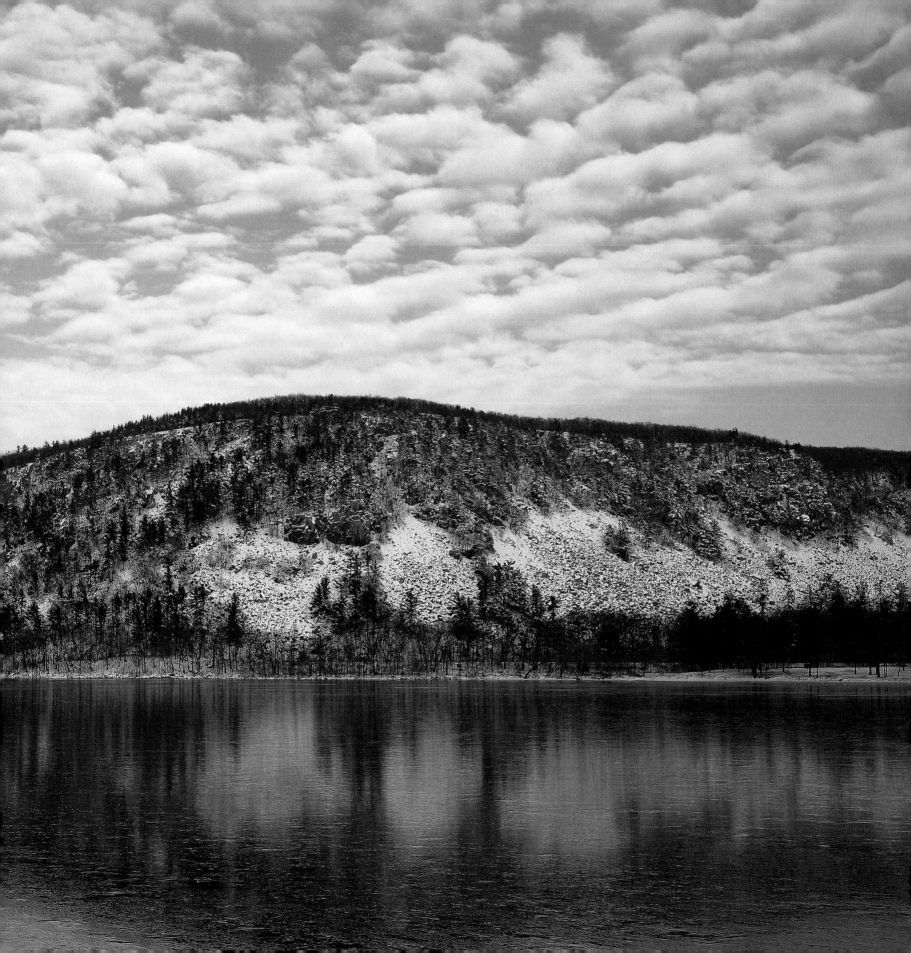

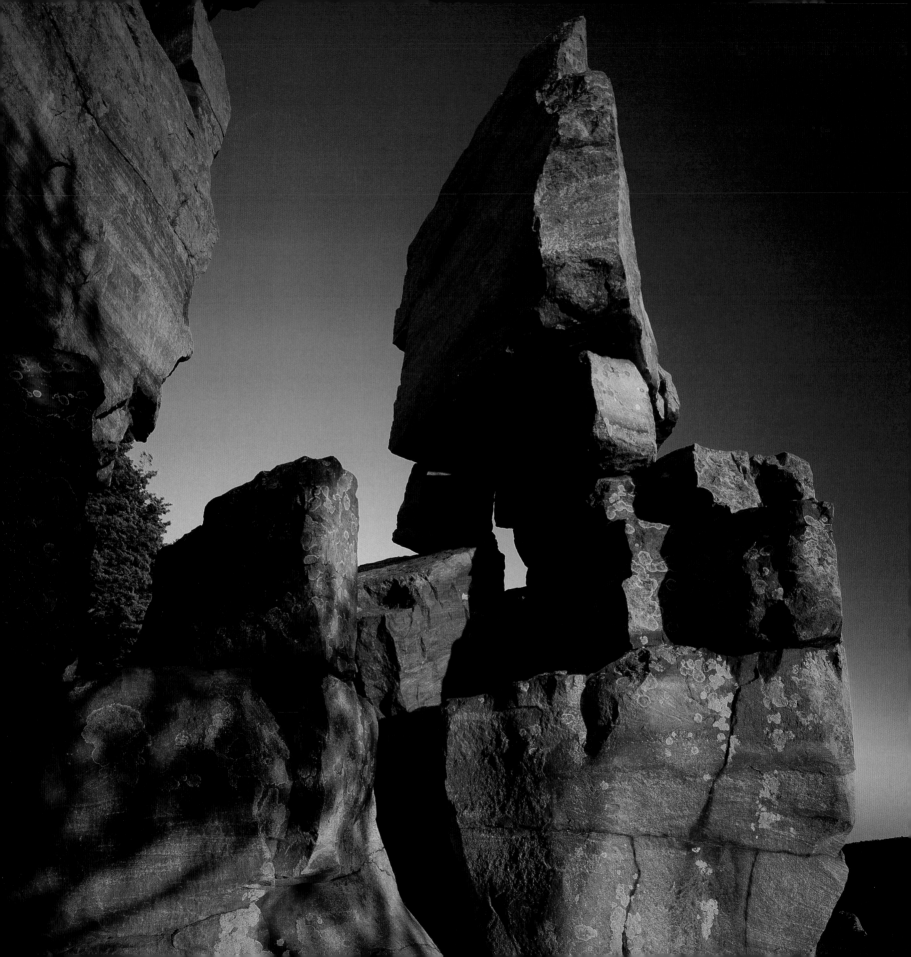

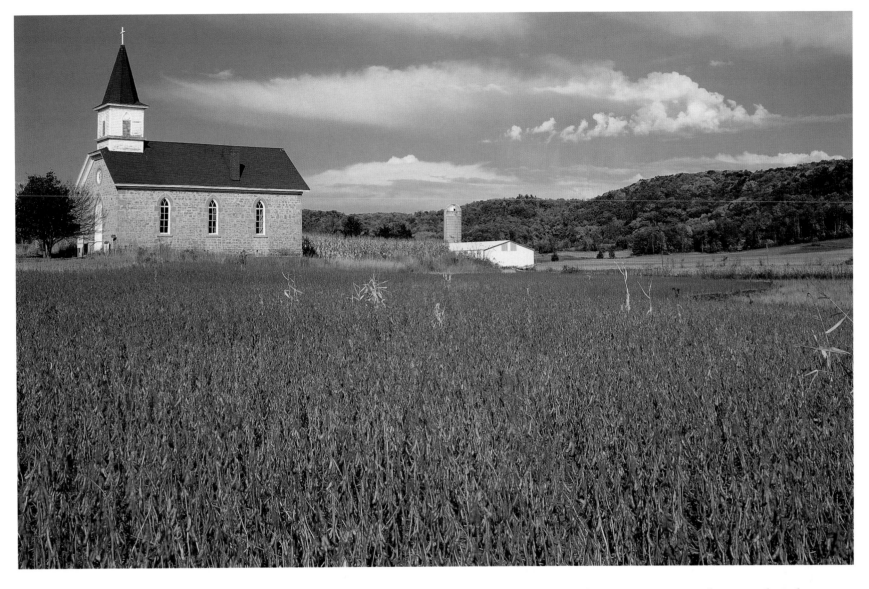

The birthplace of the Ringling Brothers Circus, Baraboo is also the gateway to wilderness adventures. Devil's Lake State Park is just a short drive away, nature trails wind through a local crane sanctuary, and geologists lead tours that reveal the region's ancient history.

The quartzite that surrounds Devil's Lake State Park was once sand. Buried five miles underground, then fused by pressure, the newly formed quartzite was forced to the surface once more by the collision of continents over a billion years ago.

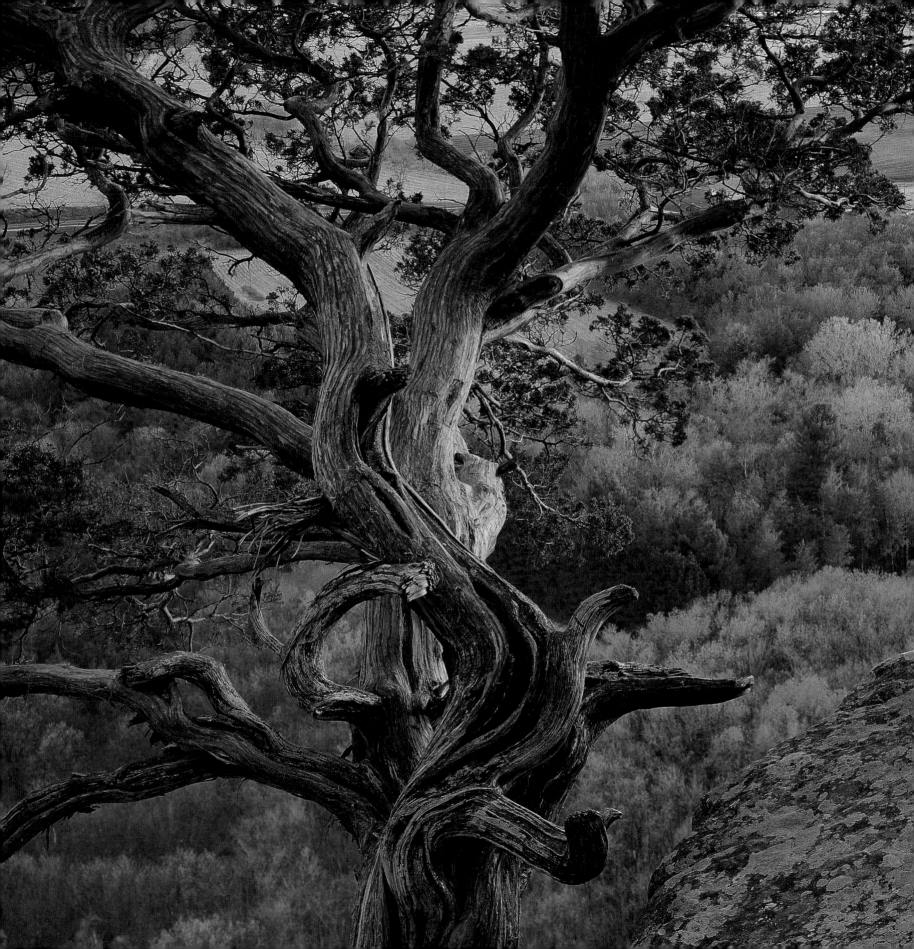

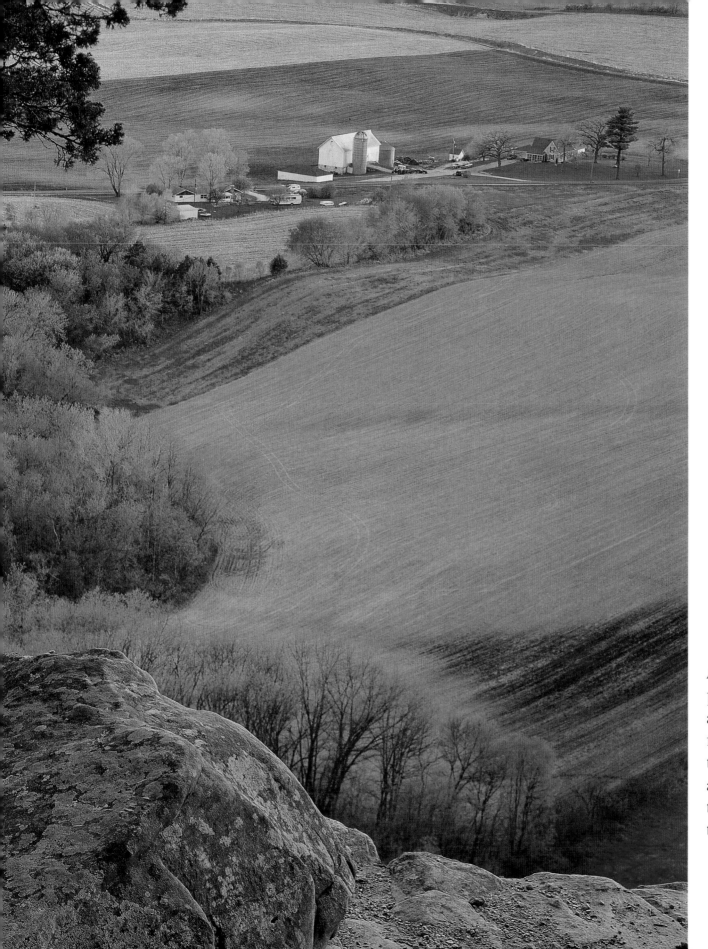

About 100 state parks in Wisconsin, along with state-maintained forests, trails, and recreation areas, draw more than 14 million tourists a year.

49

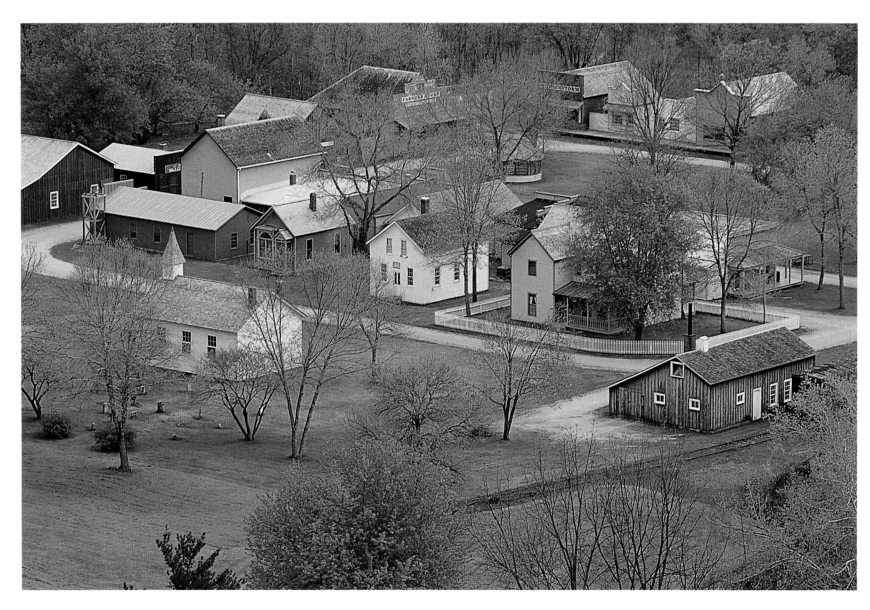

The 1893 home of Nelson Dewey, Wisconsin's first governor, is preserved at Stonefield Village Historic Site. Nearby, 30 reconstructed buildings offer a glimpse of what life might have been like in an eighteenth-century rural town.

Known for its artists' studios and antique shops, the quaint community of Mineral Point lies in the state's southwest corner. The town was named by prospectors who came to the region in search of lead during the 1820s.

Mineral Point's nineteenth-century settlers – hard-rock miners from Cornwall, England – left their mark in the community. Limestone and sandstone buildings stand as testaments to their skills as stonemasons, while delights such as pasty and figgy-hobbin attest to the talents of Cornish bakers.

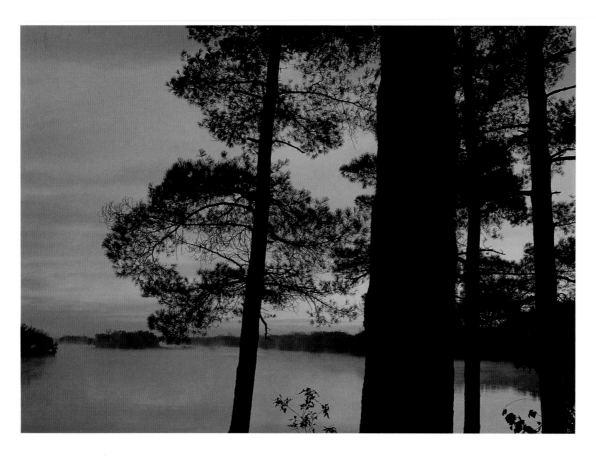

Once the traditional hunting territory of the Iowa native people, Iowa County was created in 1839 – the third county in the state.

From 1911 until 1959, architect Frank Lloyd Wright lived and worked at Taliesin, a farm-like refuge that eventually grew into a sprawling estate. In recognition of his achievements, the federal government declared this a national historic landmark in 1976.

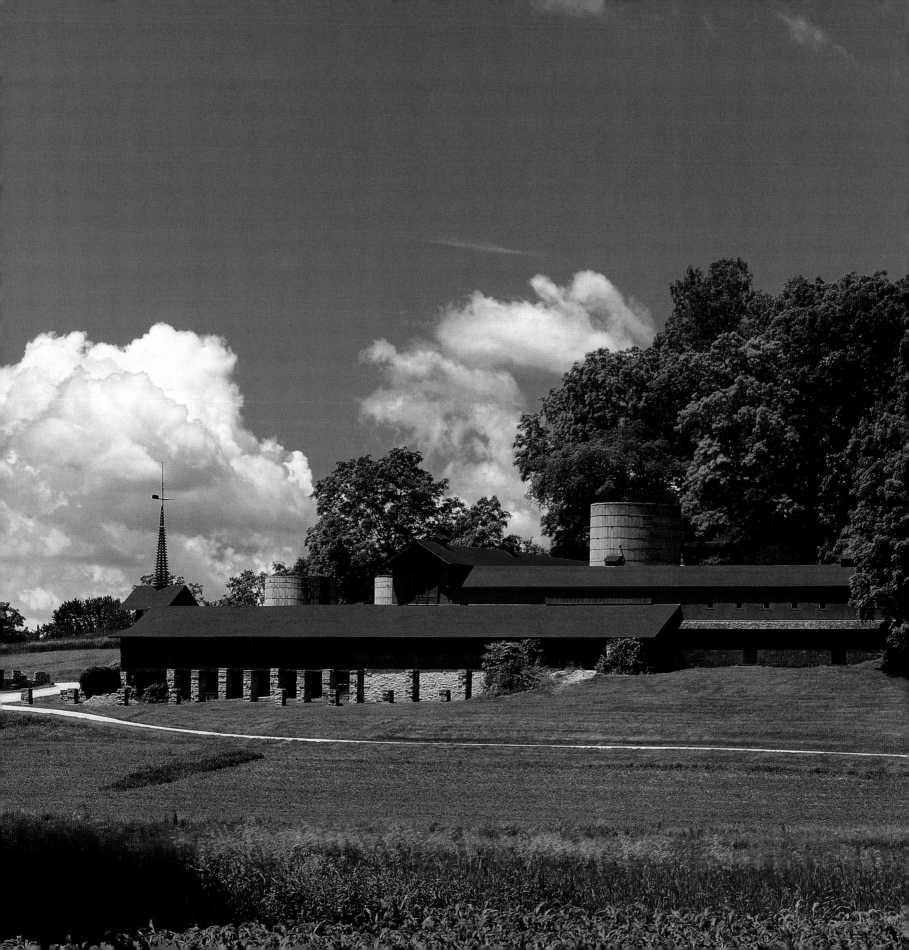

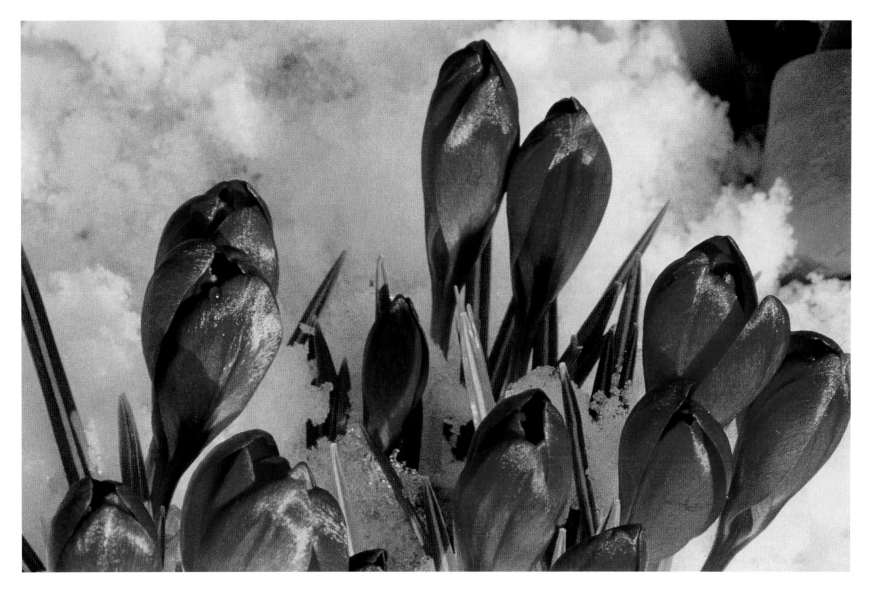

This delicate crocus is a member of the buttercup family. The plant's small purple flowers appear just after the last snow melts – or occasionally even earlier.

In 1909, landscape architect John Nolen submitted a proposal for a park system to the state government. In it, he wrote, "simple recreation in the open air...contributes to physical and moral health, to a saner and happier life."

Named for the
fourth president of
America, Madison
was founded by
James Duane Doty,
a judge and specu-
lator who bought
1,200 acres here
in 1829. He later
convinced the newly
created legislature to
designate this the
territorial capital.

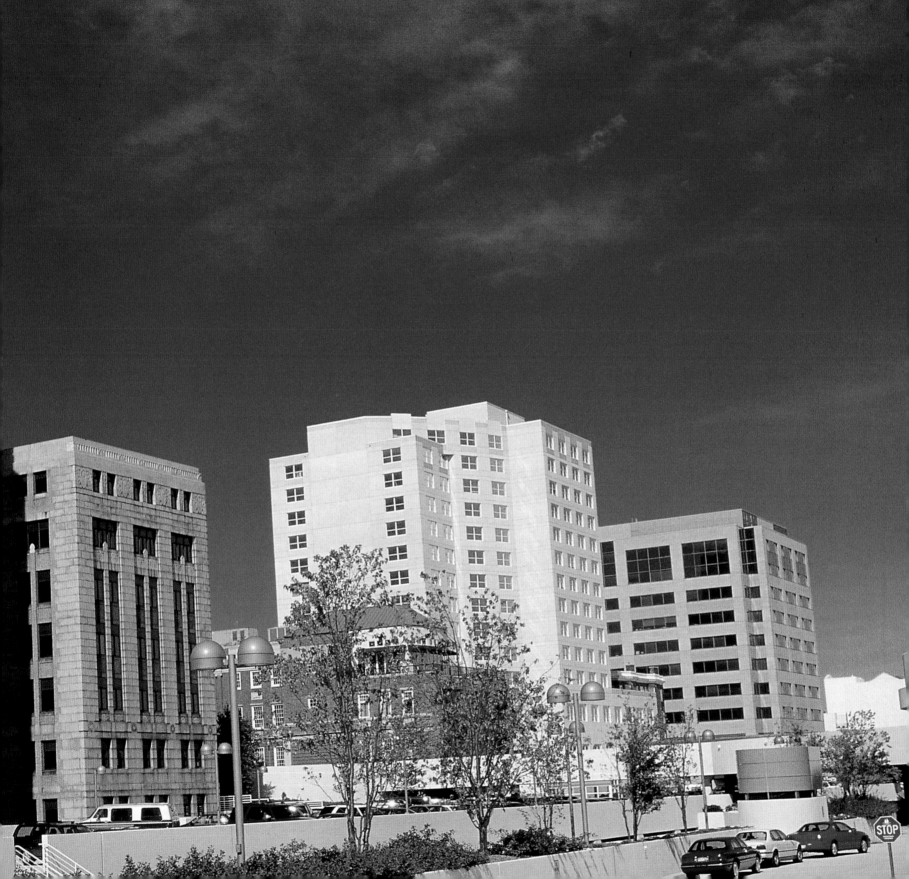

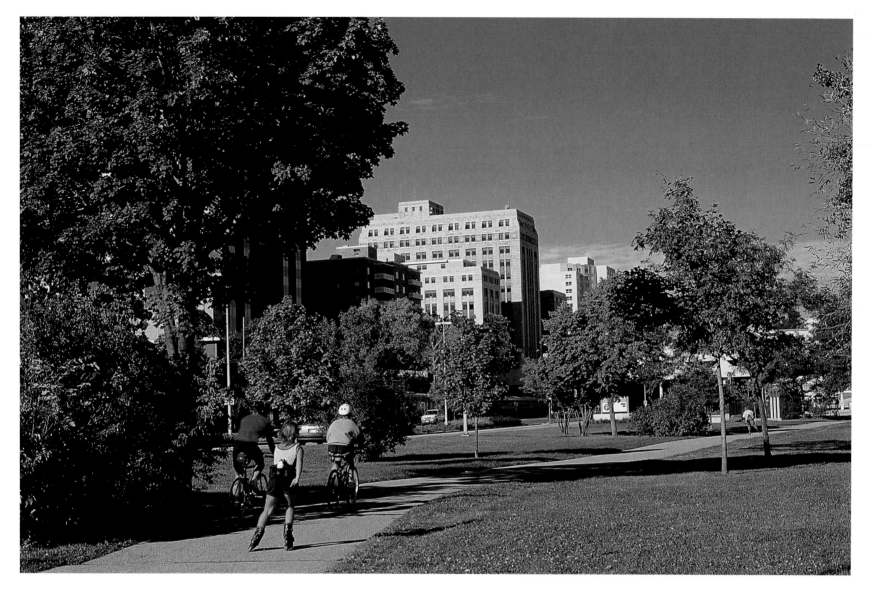

Madison lies on an isthmus between lakes Monona and Mendota.
The city is a recreational paradise, with two other lakes, over
200 parks, 21 golf courses, and more.

Wisconsin's first state capitol was built in 1838, and stood for a
quarter century before it was replaced in 1863. When the second
capitol was destroyed by fire, the present building was created. It
was designed by George B. Post & Sons and completed in 1917.

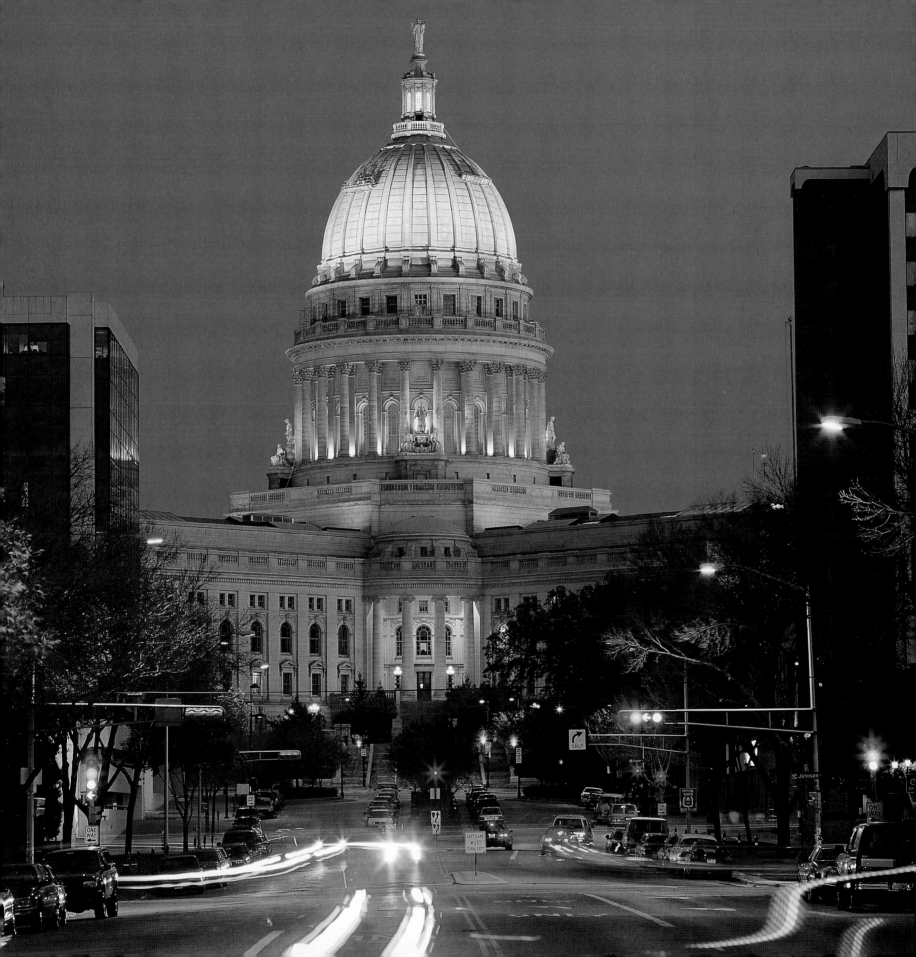

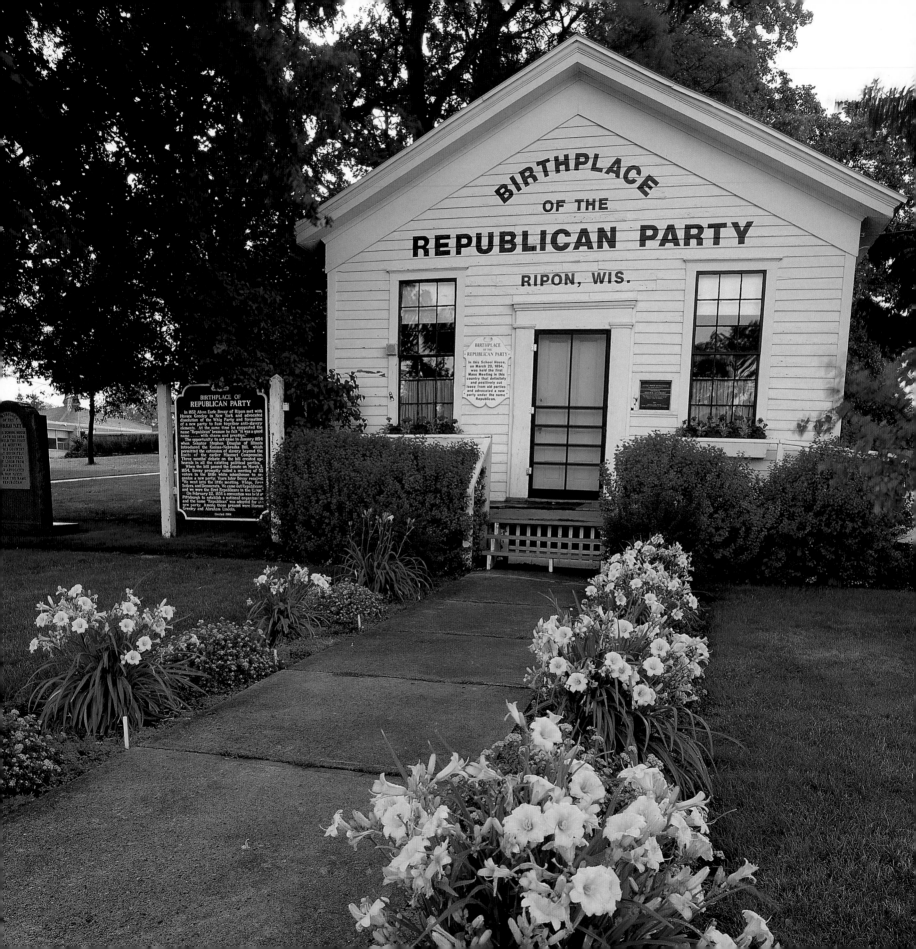

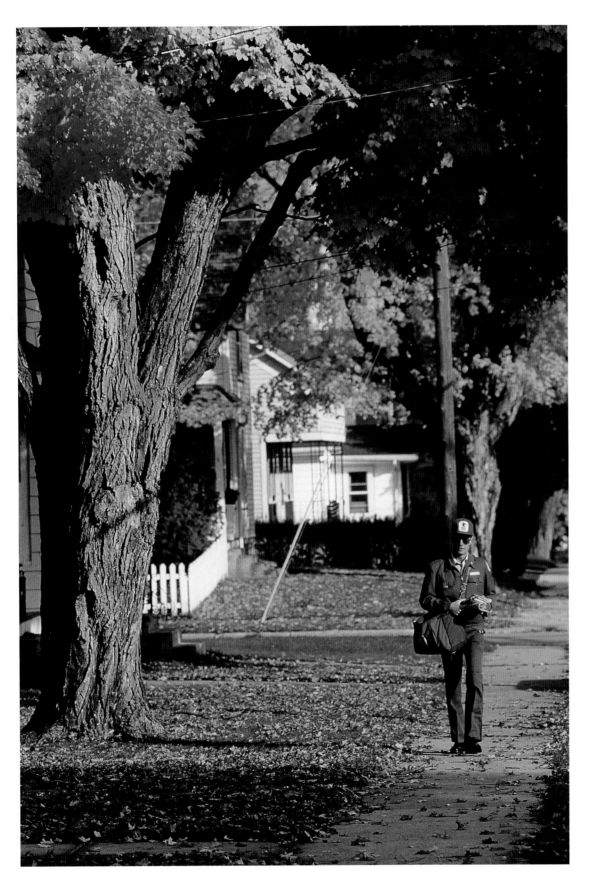

Home to about 10,000 people, Waupun lies in the rolling hills of central Wisconsin, just a few miles from some of the state's best fishing lakes and surrounded by cycling and hiking trails.

FACING PAGE—
In 1854, Ripon lawyer Alvan Earle Bovay led a meeting in the local school-house, convincing 54 fellow voters (out of 100 in the area) to create a new politi-cal organization – the Republican Party. Today, the Little White Schoolhouse where the party was born is a protected historic site.

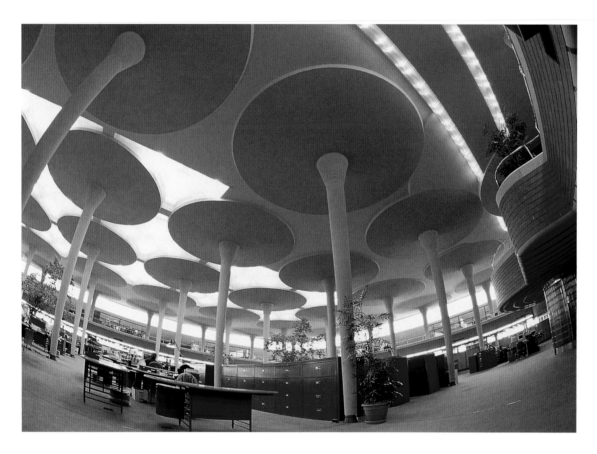

Frank Lloyd Wright created Johnson Wax's corporate offices in Racine in the 1930s. Along with the distinctive columns, the architect designed the building's furniture, including office chairs that tip if workers don't sit with proper posture.

Milwaukee is the state's largest manufacturing center, and has earned the nickname of Machine Shop of America. Harley-Davidson motorcycles are made here, along with mining tools and automotive parts.

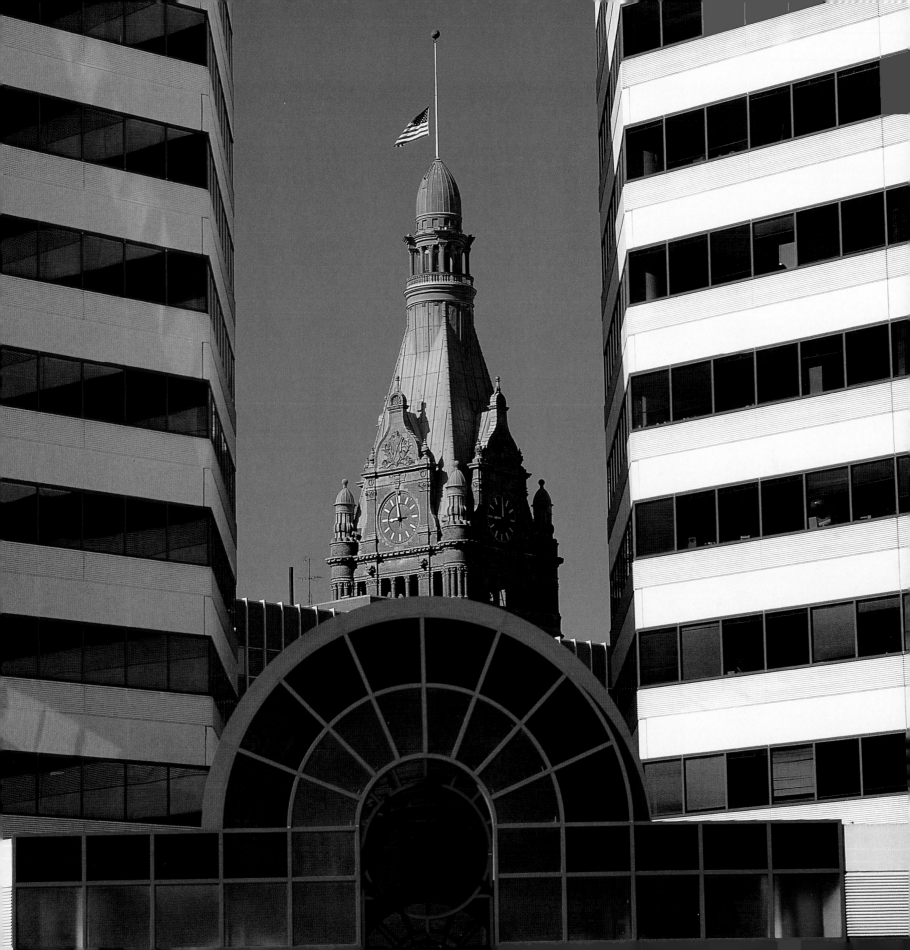

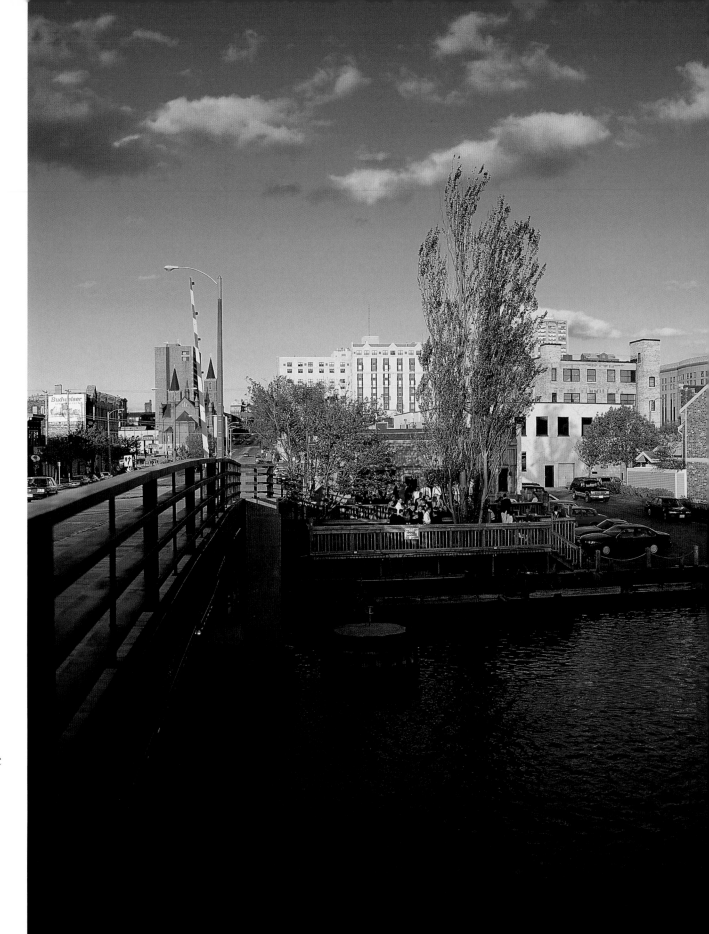

Thousands of years ago, Milwaukee was a meeting site for native travelers and traders. The city's name comes from the native word *milliocki*, or "gathering place by the waters."

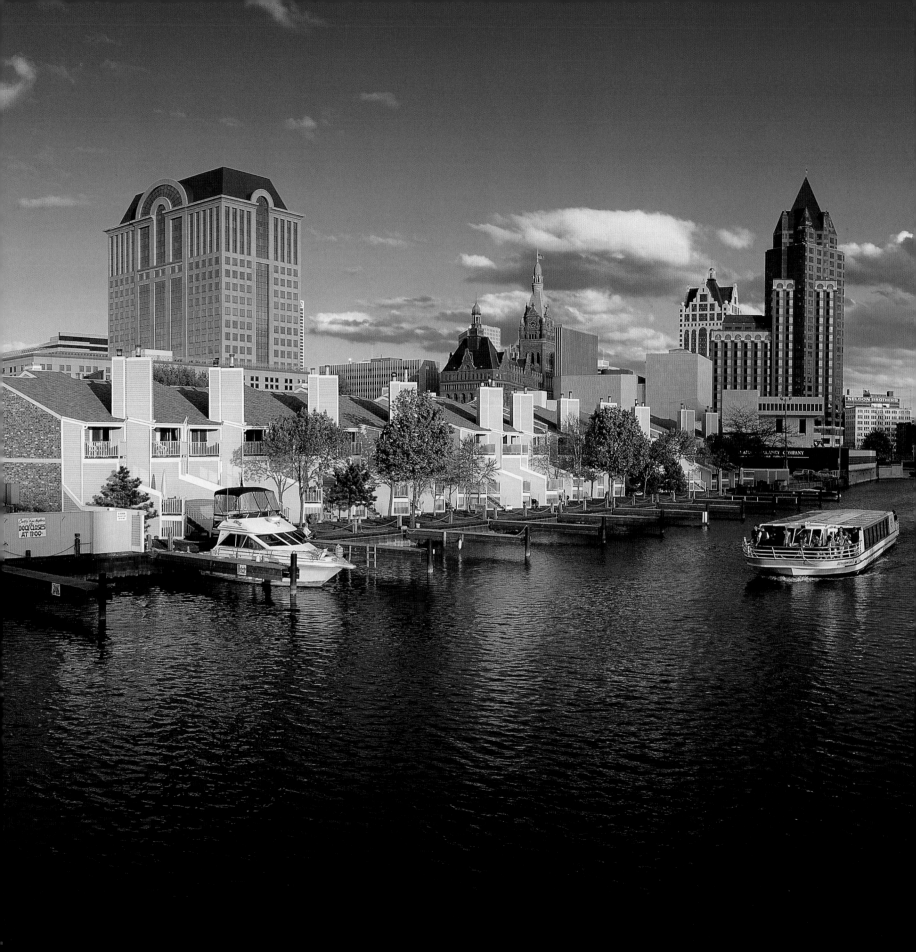

The city's eclectic mix of culture and commerce draws millions of visitors each year. Flights arrive nonstop from 90 cities around the world, and there are more than 4,000 hotel rooms in the downtown area.

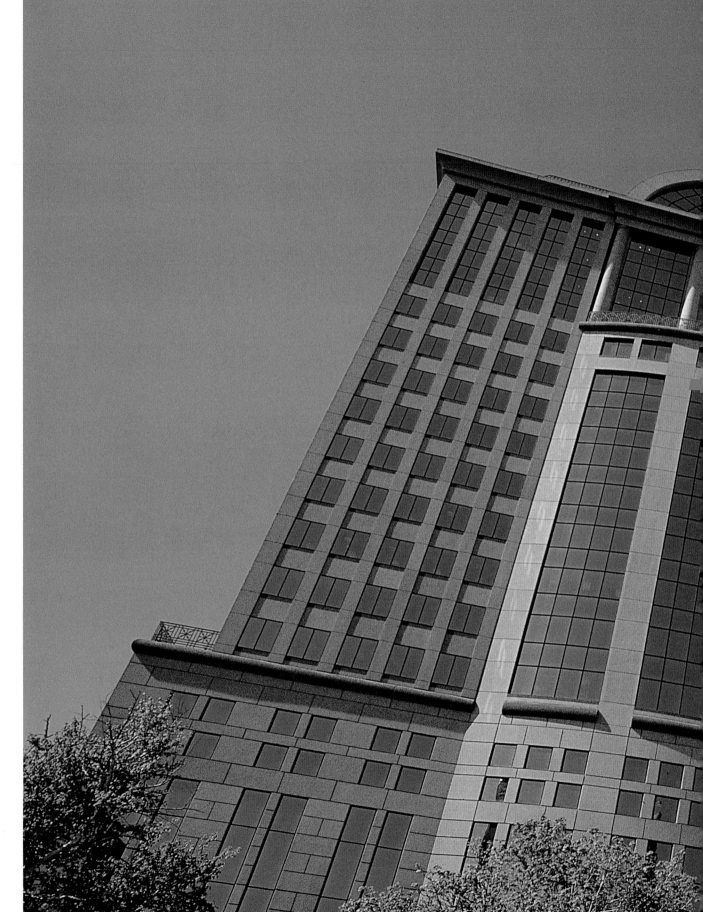

From historic Brady Street, where nine-teenth-century Irish, German, and Polish settlers made their homes, to East Town's theater district and downtown's cosmopolitan bustle, each of Milwaukee's neighborhoods has a unique flavor.

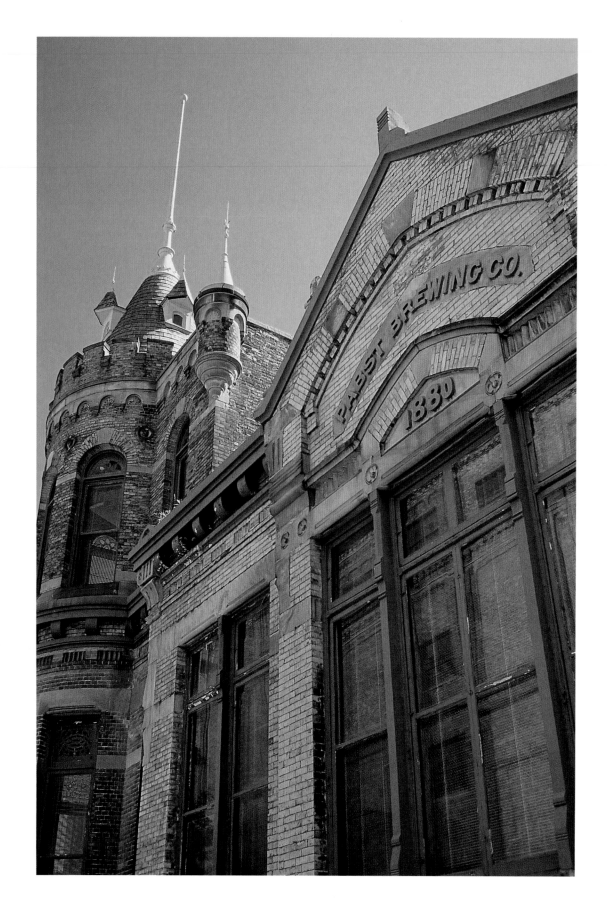

A partnership formed in the 1840s between brewer Jacob Best and steamship captain Frederick Pabst was cemented when Pabst married Jacob's daughter, Maria. Their brewing empire still exists as Pabst Brewing Company.

Though prohibition temporarily drove the industry underground, brewing has always been a large part of Milwaukee's economy. This city is most famous as the home of Miller beer.

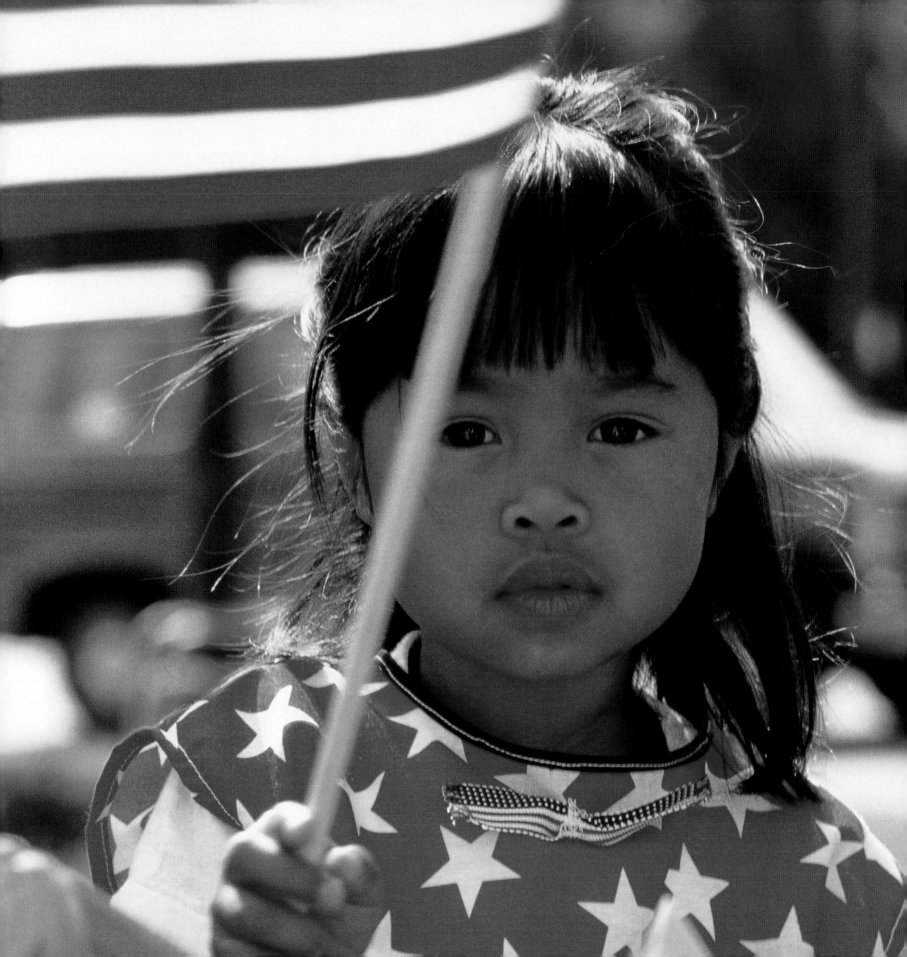

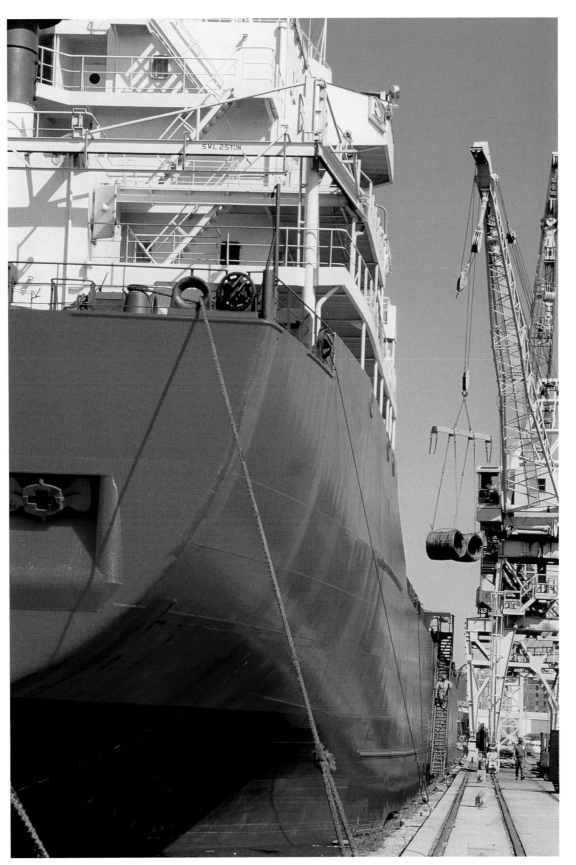

The first ship called at Milwaukee's port in 1835. Sixteen vessels can now berth here, loading and unloading steel, timber, farm and construction machinery, and more.

FACING PAGE—
Children take part in a Fourth of July parade. Among its many festivals, Milwaukee hosts CajunFest in June, Irish Fest in August, Oktoberfest in September, and countless other cultural events throughout the year.

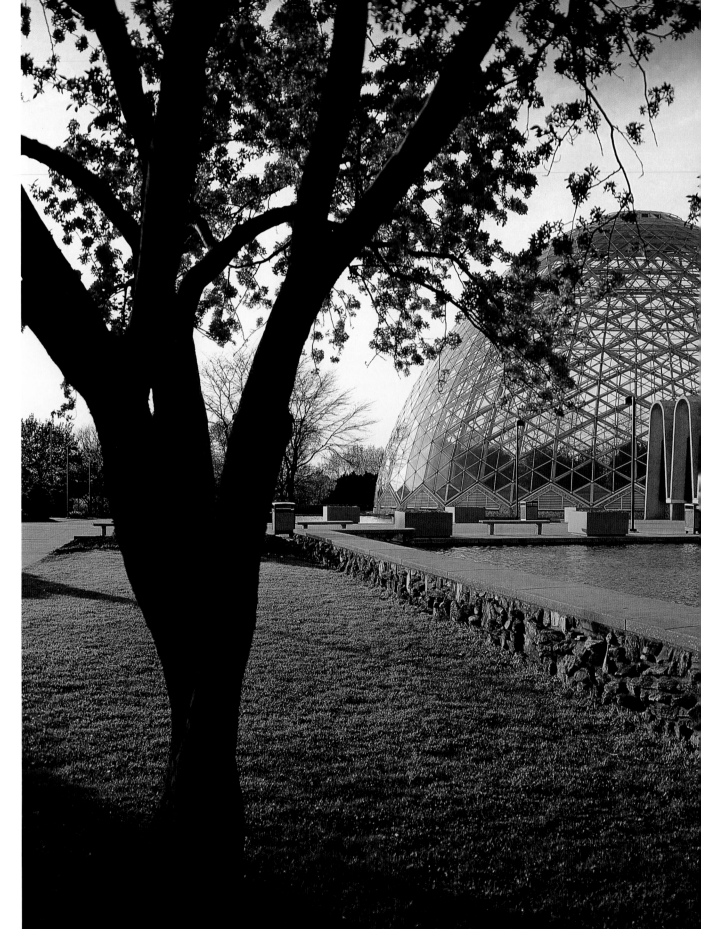

The Mitchell Park Horticultural Conservatory – better known in Milwaukee as The Domes – leads sightseers from the deserts of Madagascar to the jungles of South America, all in a single afternoon. Each dome shelters a different ecosystem.

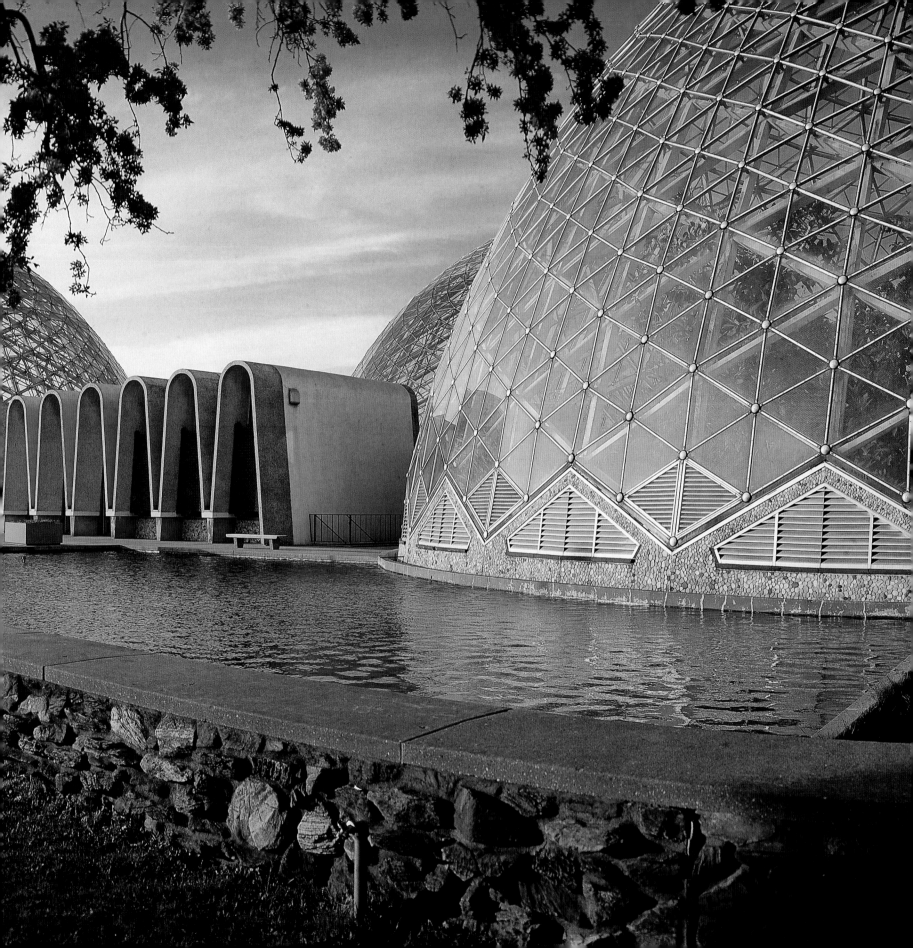

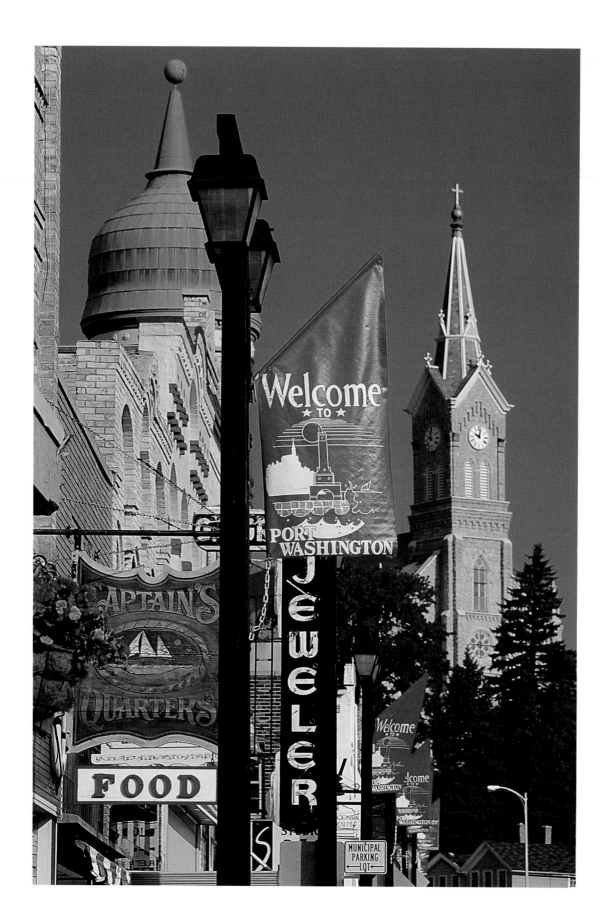

Rising from the waters of Lake Michigan to the 100-foot bluffs above, Port Washington has been drawing scenery-lovers since the community was incorporated in 1848 – the same year Wisconsin became a state.

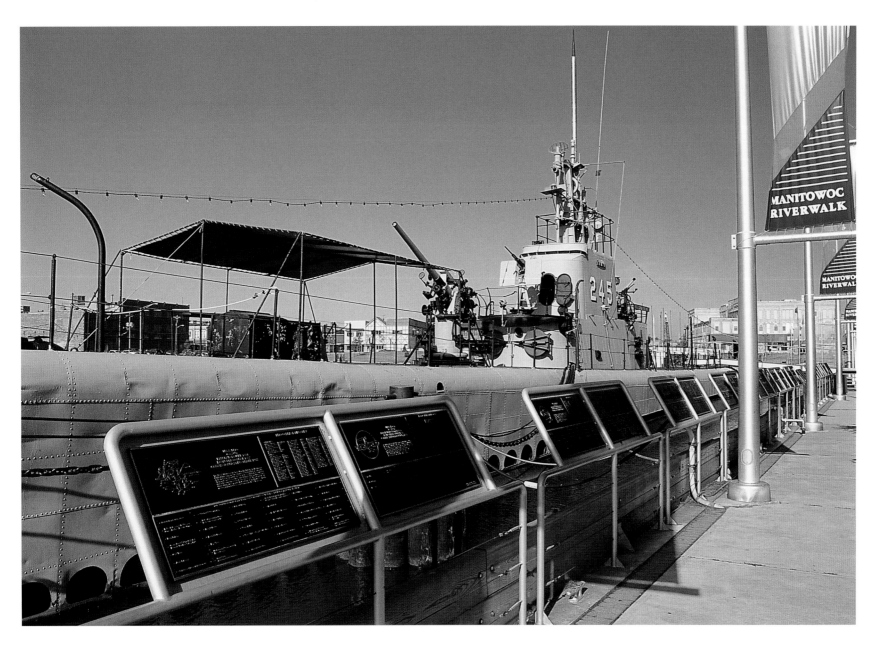

In Manitowoc, billed as Wisconsin's maritime capital, the largest maritime museum on the Great Lakes displays sights such as historic sailing ships and a wartime submarine.

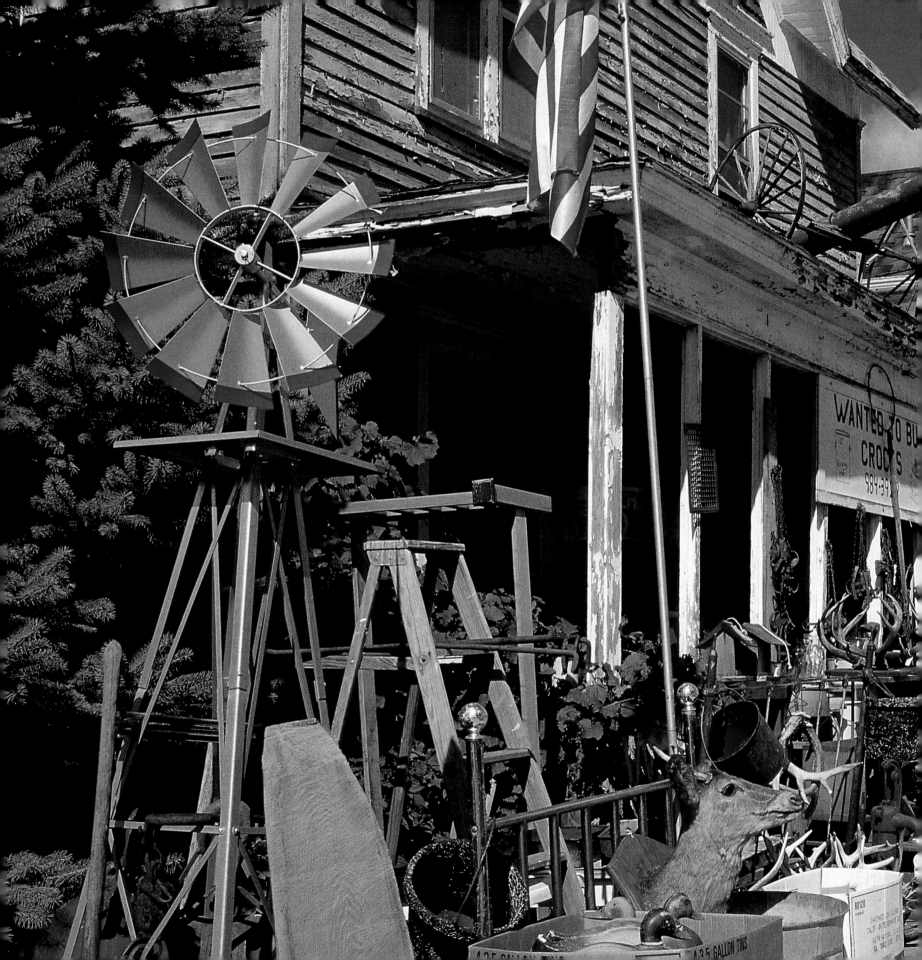

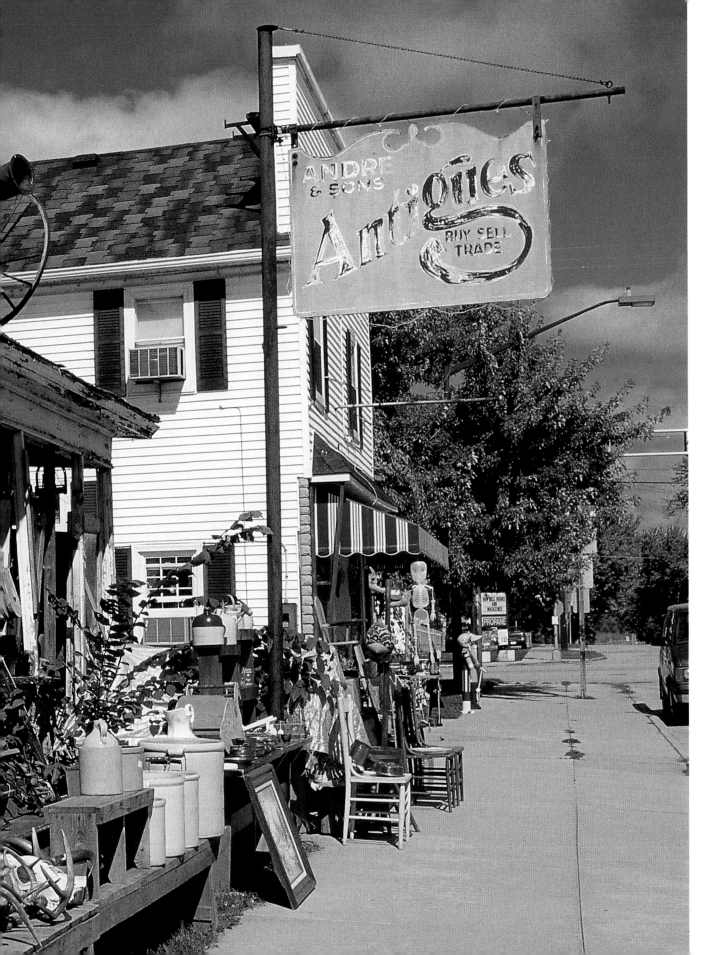

With 90 antique malls and hundreds of small galleries such as this one in Black Creek, southern Wisconsin is an antique-hunter's paradise. From jewelry and books to eighteenth-century furniture, there is something to catch everyone's eye.

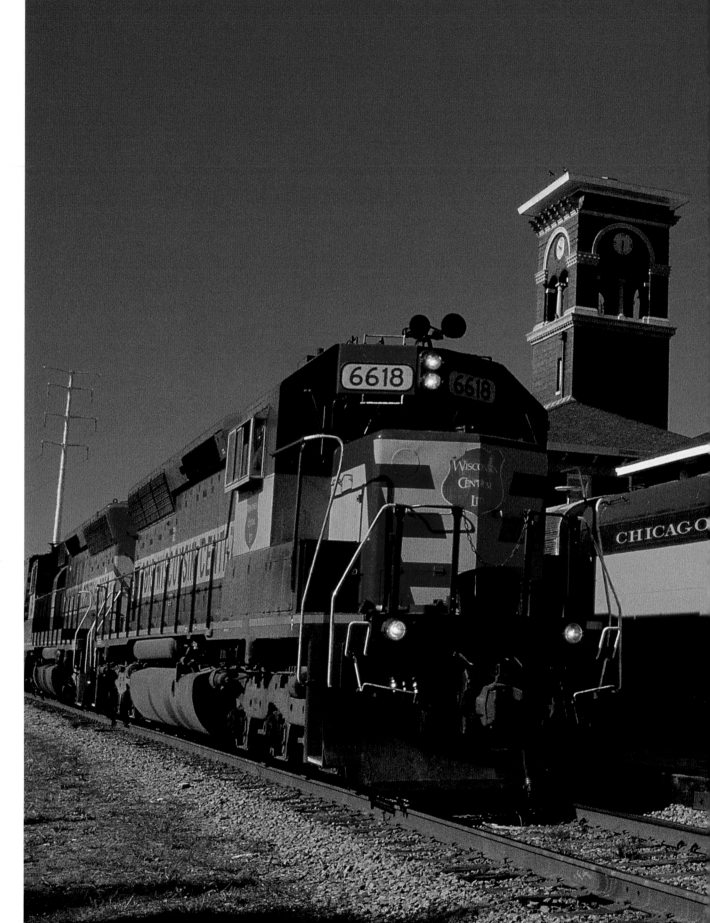

The National Railroad Museum in Green Bay was the brainchild of General Carl R. Gray, director general of the Military Railway Service during World War II. It is dedicated to preserving the equipment and history of the nation's rail lines.

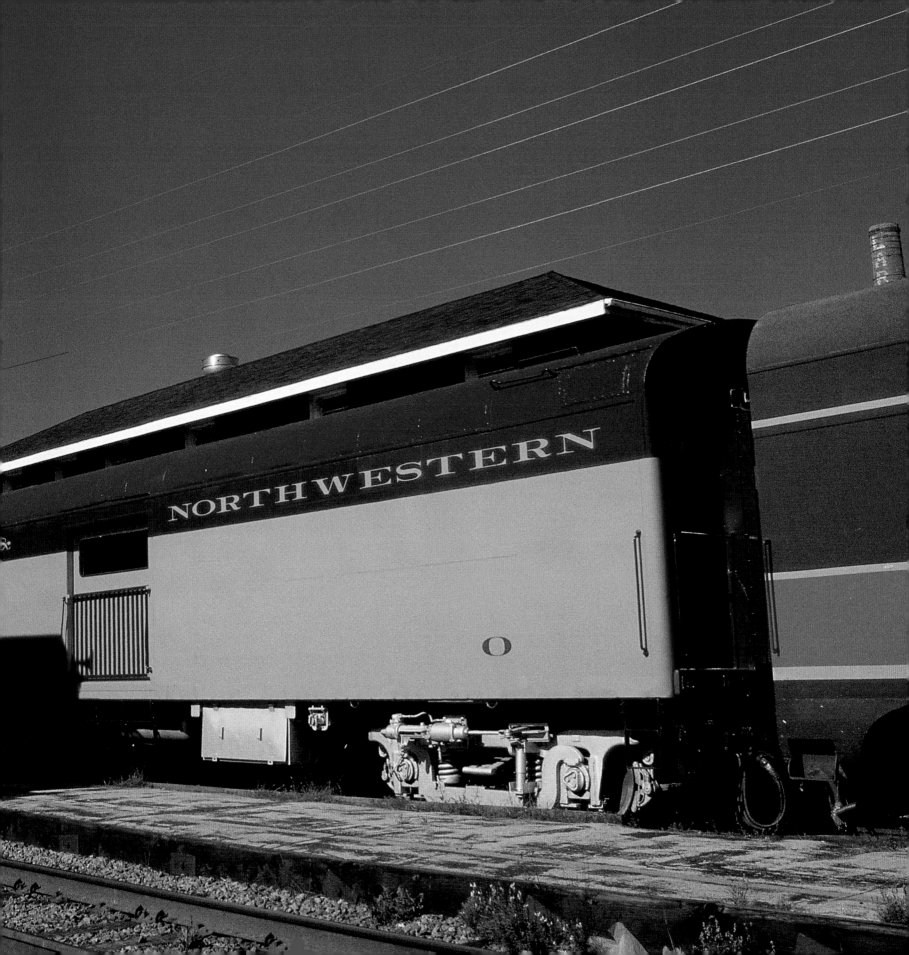

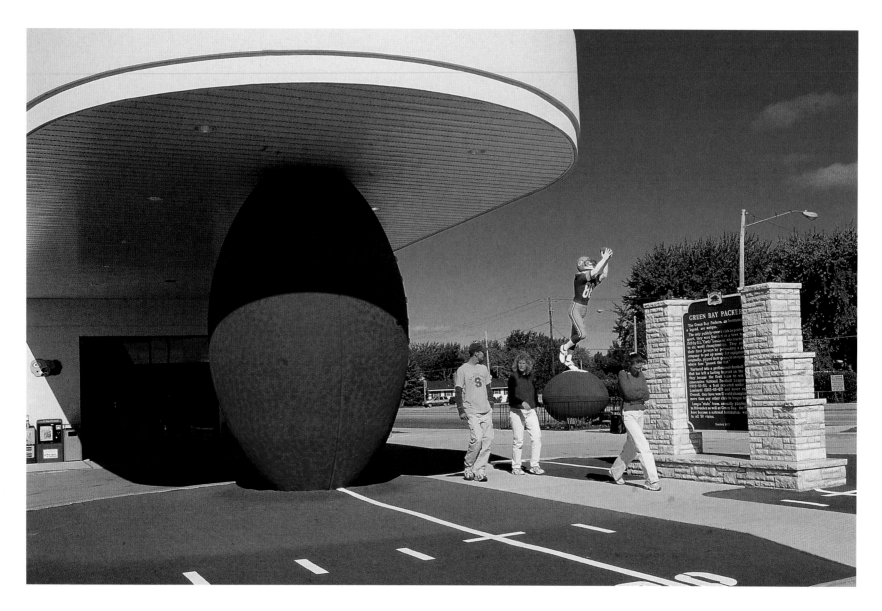

After 80 years and 12 championships, the Green Bay Packers are still one of the most popular football teams in the NFL. Waiting lists for season tickets are several years long and the 60,790-seat stadium is regularly packed with fans.

Commissioned by the governor of New France, explorer Jean Nicolet was the first European to travel Door County. He charted the shores in search of a water route across the continent.

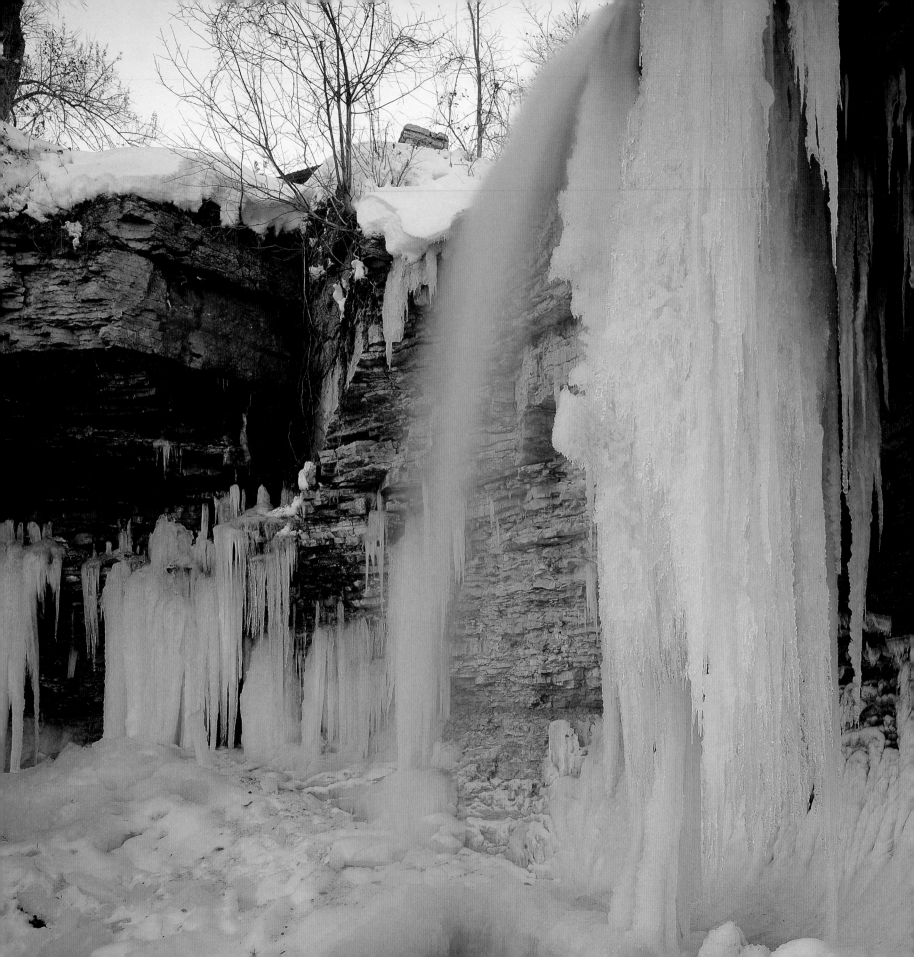

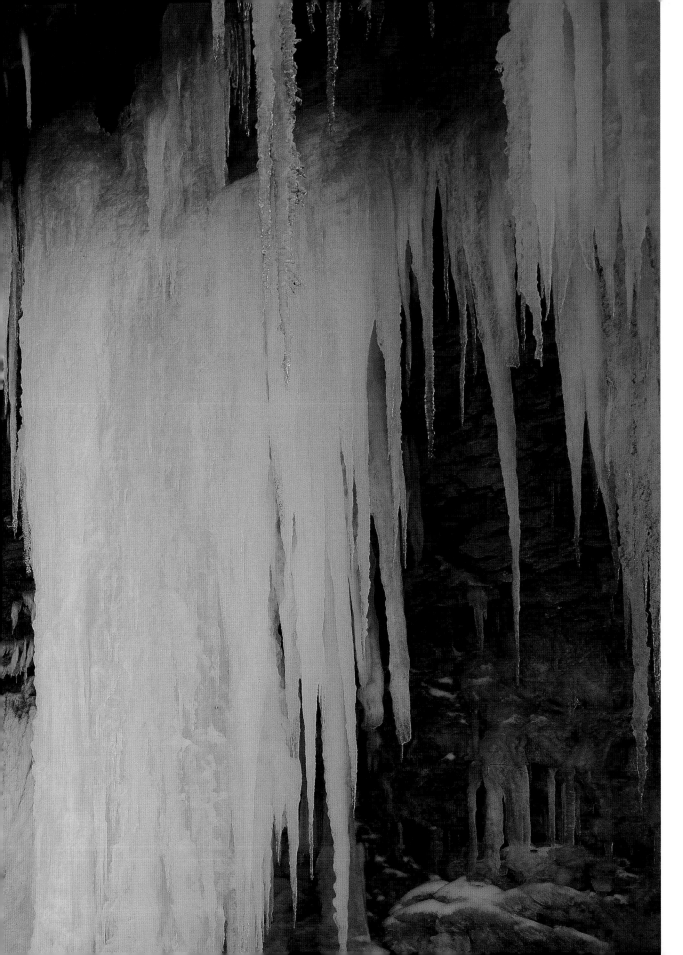

There are more than 60 waterfalls in Wisconsin, some just steps away from the highway and others only accessible by foot.

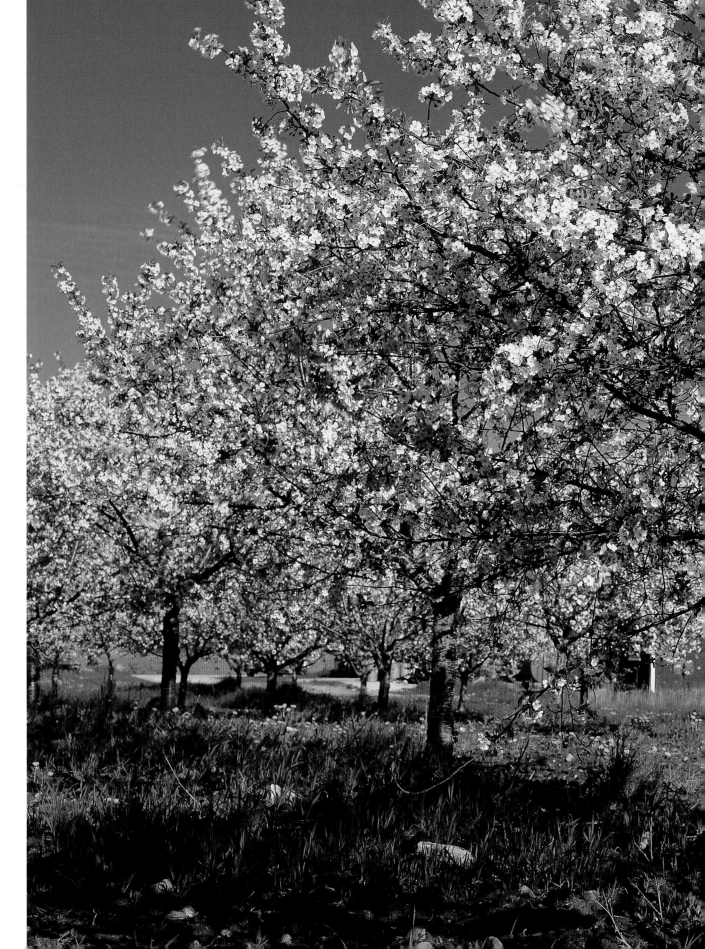

Only 75 miles long, the Door County peninsula is home to 4,000 acres of cherry and apple orchards. A bumper crop can produce 10.5 million pounds of cherries.

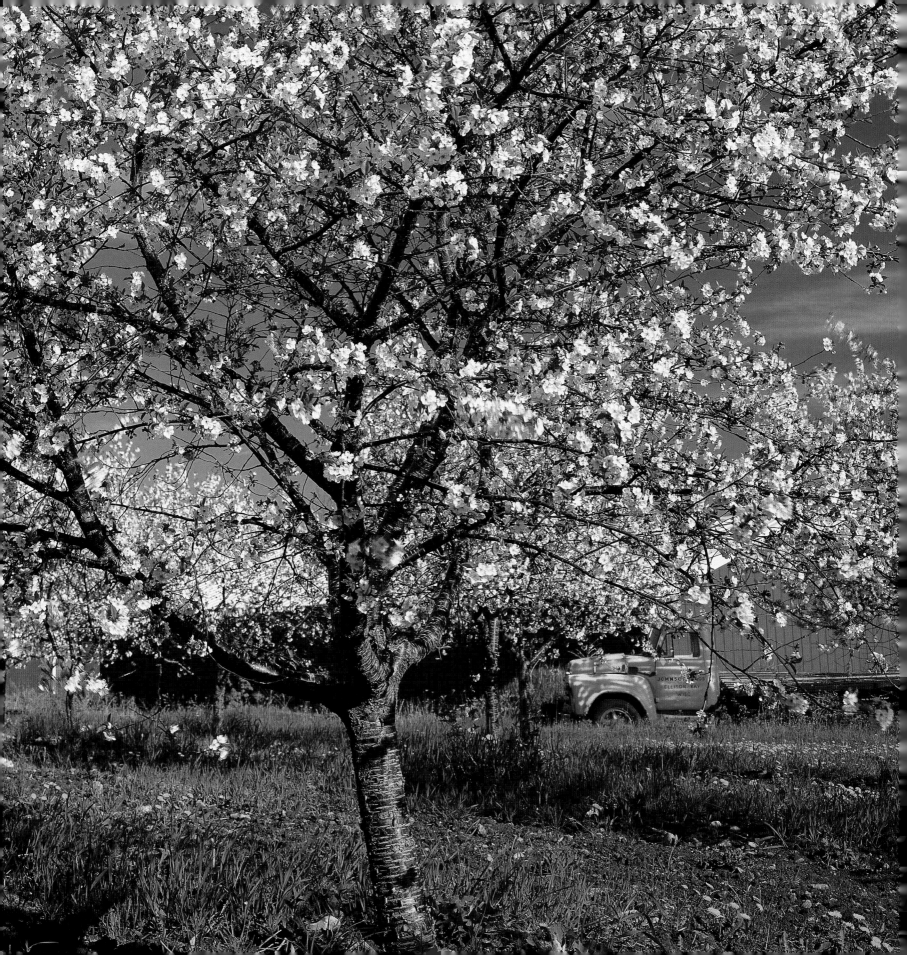

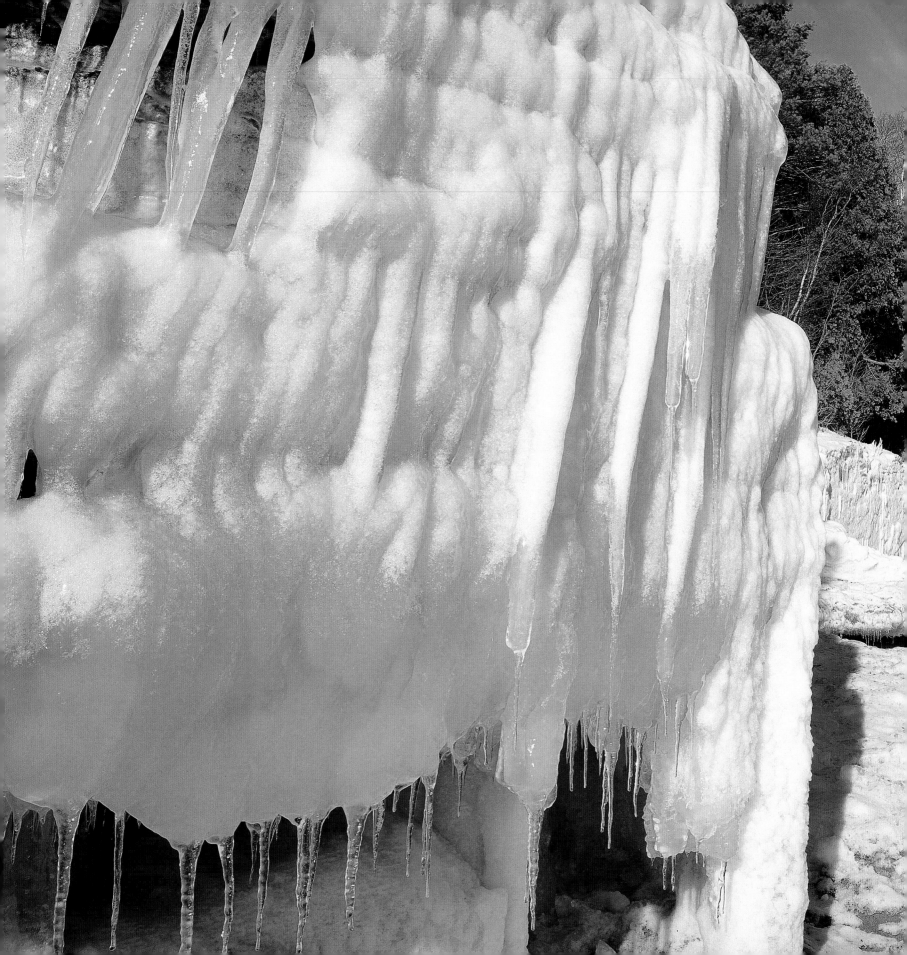

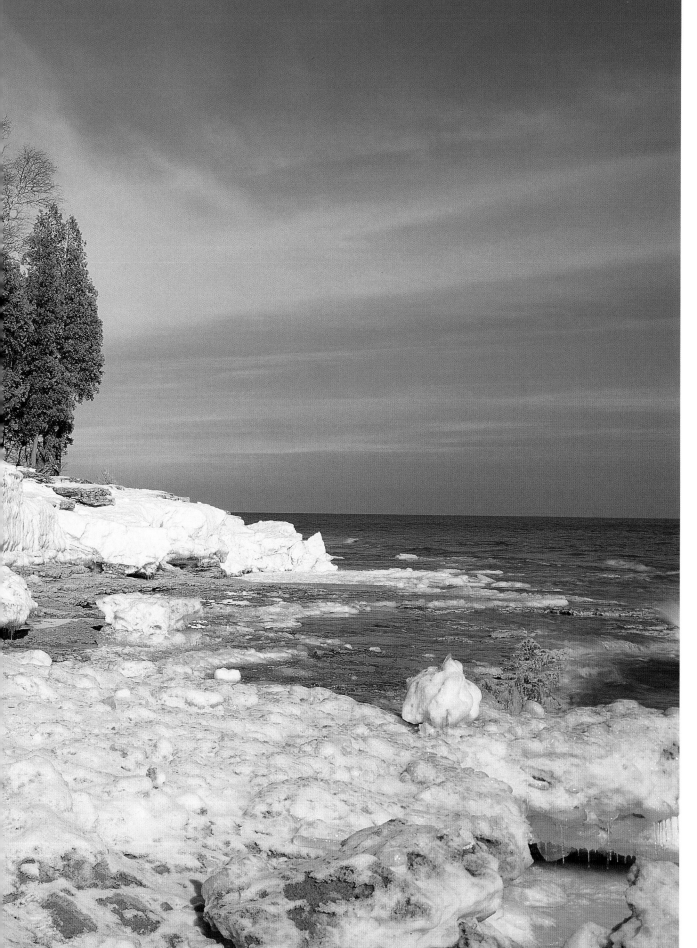

Icicles hang from the limestone bluffs in Cave Point County Park. The waves of Lake Michigan, pounding the limestone for centuries, have created unusual sea caves within the park.

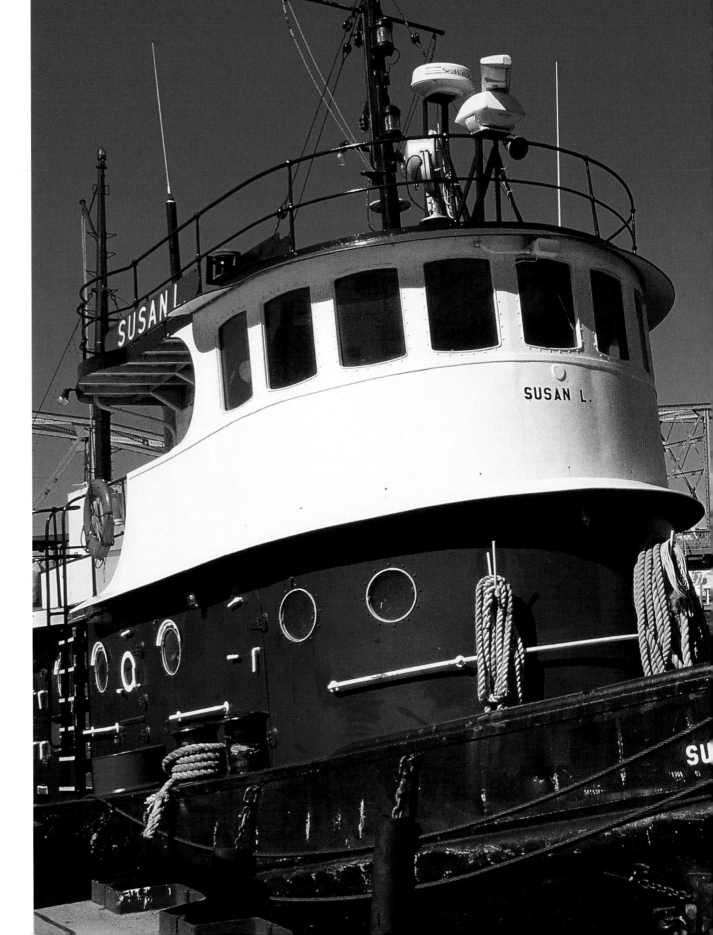

After centuries of shipbuilding, Sturgeon Bay is now home to the Door County Maritime Museum, preserving the history of the vessels made here, from birch-bark canoes to luxury yachts.

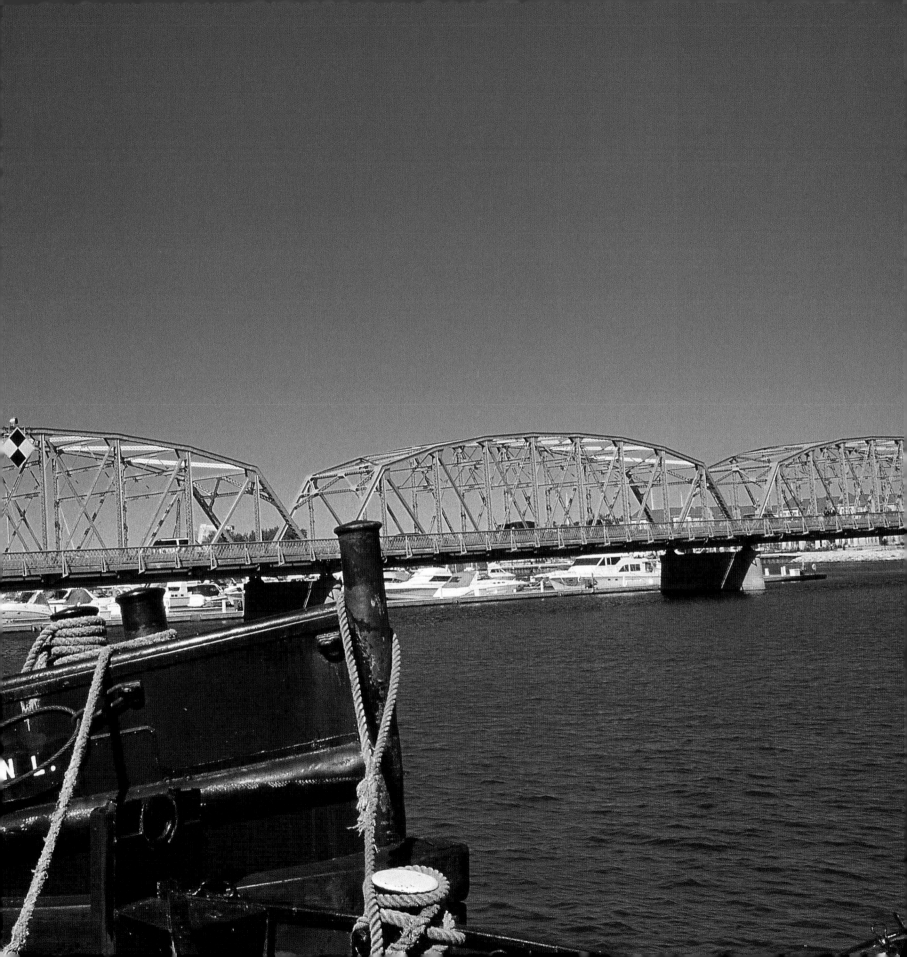

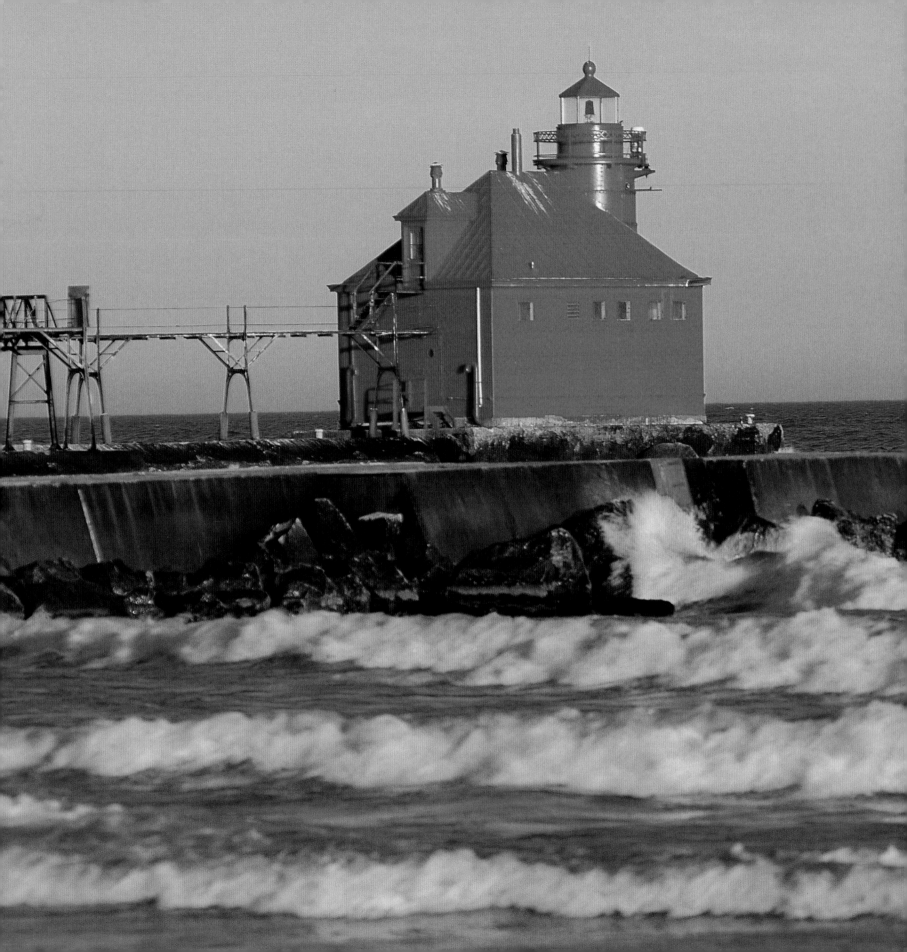

When French explorers first charted the tip of the Door County peninsula, they called the dangerous waters Porte des Morts, or "door of the dead." Today, Door County boasts 10 lighthouses – more than any other county in the United States.

Photo Credits

Terry Donnelly 1, 3, 6-7, 8, 9, 10-11, 12, 13, 14, 15, 16-17, 19, 22, 23, 25, 26-27, 28-29, 30, 31, 32-33, 34, 35, 36, 37, 38-39, 40-41, 47, 48-49,50, 51, 52-53, 54, 55, 61, 62, 78, 85, 88-89, 90-91, 94-95

Jürgen Vogt 18, 58-59, 60, 64, 72, 80-81, 82-83, 84, 92-93

Phyllis Kedl/Unicorn Stock Photos 20-21

Zane Williams/Mach 2 Stock 24, 63

Mary Liz Austin 42

Tom Till 43, 44-45, 46, 86-87

Steve Mulligan 56

Ken Wardius/Mach 2 Stock 57

Peter Saunders/Mach 2 Stock 65, 66-67, 70-71, 76-77

Scott J. Witte/Mach 2 Stock 68-69, 73, 75

Susan Lina Ruggles/Mach 2 Stock 74

Andre Jenny/Unicorn Stock Photos 79